The Watercolorist's Essential Notebook

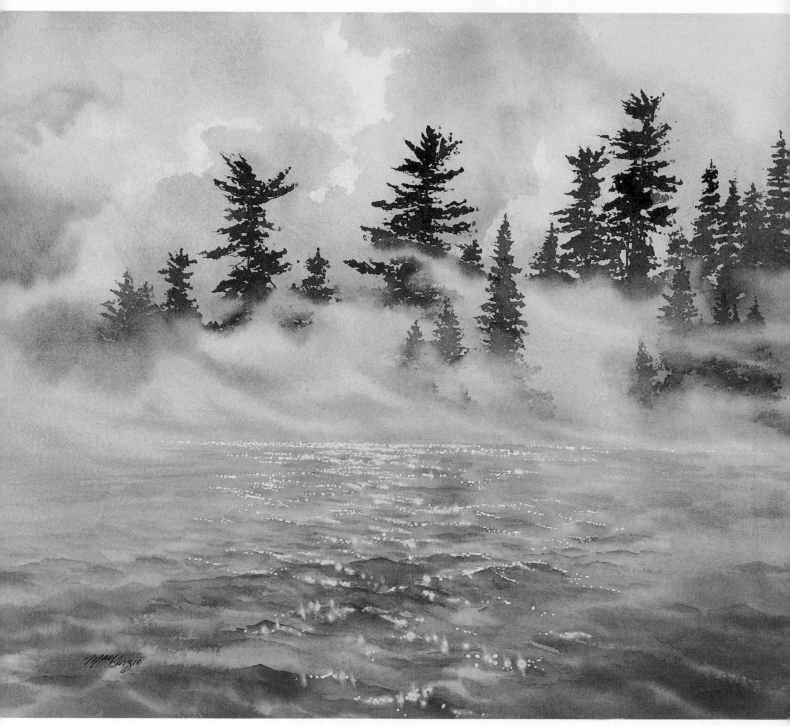

MORNING DIAMONDS
Watercolor on 300 lb. Arches medium cold-press paper,
19" x 22" (48cm x 56cm)
Collection of the artist
Photographer: Kevin Dobie, Kevanna Studios

The Watercolorist's Essential Notebook

Gordon MacKenzie

NORTH LIGHT BOOKS
Cincinnati, Ohio
www.artistsnetwork.com

DEDICATION

This book is dedicated to the members of my family who gave up so much over the years so that I could pursue a painting career. I thank Jane, for her patience and understanding; Sandra, whose creative light fills my world; Michael, our oldest soul showing us the way; Barry, who keeps me in touch with nature; Cathie, who stabilizes her young family with love; and Rianne and Nicholas, our hope for the future. Also Don, an artist in wood; Pam, an artist in fabric; and Vera, who started it all by giving me my first paints.

The Watercolorist's Essential Notebook. Copyright © 1999 by Gordon MacKenzie. Manufactured in China. All rights reserved. No part of this book may be reproduced in any form or by any electronic or mechanical means including information storage and retrieval systems without permission in writing from the publisher, except by a reviewer, who may quote brief passages in a review. Published by North Light Books, an imprint of F+W Publications, Inc., 4700 East Galbraith Road, Cincinnati, Ohio 45236. (800) 289-0963. First edition.

15 14 13 12 11 18 17 16 15 14

Library of Congress Cataloging-in-Publication Data

MacKenzie, Gordon, 1939–
 The watercolorist's essential notebook / Gordon MacKenzie.
 p. cm.
 Includes index.
 ISBN-13: 978-0-89134-946-4
 ISBN-10: 0-89134-946-4
 1. Watercolor painting—Technique. I. Title.
ND2420.M33 1999 99-40862
751.42'2—dc21 CIP

Edited by Pamela Wissman
Production edited by Nancy Pfister Lytle
Designed by Brian Roeth
Interior production by Ruth Preston
Production coordinated by Kristen Heller
Cover illustration by Gordon MacKenzie

ABOUT THE AUTHOR

Gordon MacKenzie is a native of New Liskeard in northern Ontario. He now lives in Sault Ste. Marie, Ontario, where he maintains his painting and closeness to the outdoors. Even though the remoteness of northern Ontario precluded any formal art instruction, that same remoteness became the inspiration and driving force behind his work. His paintings reflect the emotional bond he has made with the natural world.

"An artist's work is a reflection of…the most significant aspects of their environment. Those perceptions are usually set at an early age, and for me it was the spirit of remote northern lakes and forests speaking in breathtaking images for the eye and timeless silence for the soul."

Gordon received his first formal art training at the Ontario College of Art while certifying as a visual arts specialist in education. Work in a variety of media followed, but none captured the transient and ethereal nature of the land as he saw it until the early 1970s when he switched to watercolors.

"The lively atmospherics and delicate transparencies of watercolors combined to present a whole new vision for me. Although my source was nature, I have always been more interested in capturing the essence of an experience than simply making a literal reproduction of a specific scene. Close contact with children and their art over the years has taught me much about the picture-making process. I've learned to use nature as a setting or stage on which to recreate and play out my memories and visions, much as children do in their work. It is these impressions from the heart that are hidden in my paint for those with kindred spirit and eye to experience."

Gordon has now retired after thirty-three years as a teacher and art consultant for the Sault Ste. Marie Board of Education. As a graduate of Laurentian University and specialist in art education, he has taught ministry of education and university-level art education courses for teachers for many years. With over twenty years of teaching private adult watercolor workshops as well, Gordon has earned a reputation as a first-class artist and instructor.

Gordon has had twenty-five solo watercolor shows in Canada and the U.S. and his work hangs in many private and corporate collections throughout Canada, the U.S., Europe, Africa and the Far East. He has found honors in several American shows, including that of the Detroit Institute of Art and the American Artist annual competition. He has been a successful participant in the last nineteen Buckhorn Art Festivals and his work has made the cover of *Readers Digest* in Canada, Switzerland, Finland, Australia and the U.S.

ACKNOWLEDGMENTS

The best way to learn something is to teach it, and the best way to teach is to learn from your students. With this in mind, I acknowledge all that I have learned over the years, both directly and indirectly, from my students. I also wish to recognize the many dear friends and colleagues whose support and direction has been invaluable to the production of this book.

And a special thanks to Jack Reid who first directed me to North Light Fine Art Books; Rachel Wolf, acquisitions editor, who made the opportunity happen; and Pam Wissman, editor, who always offered words of encouragement and sound advice all along the way.

TABLE OF CONTENTS

3 Putting Together Your Composition...64

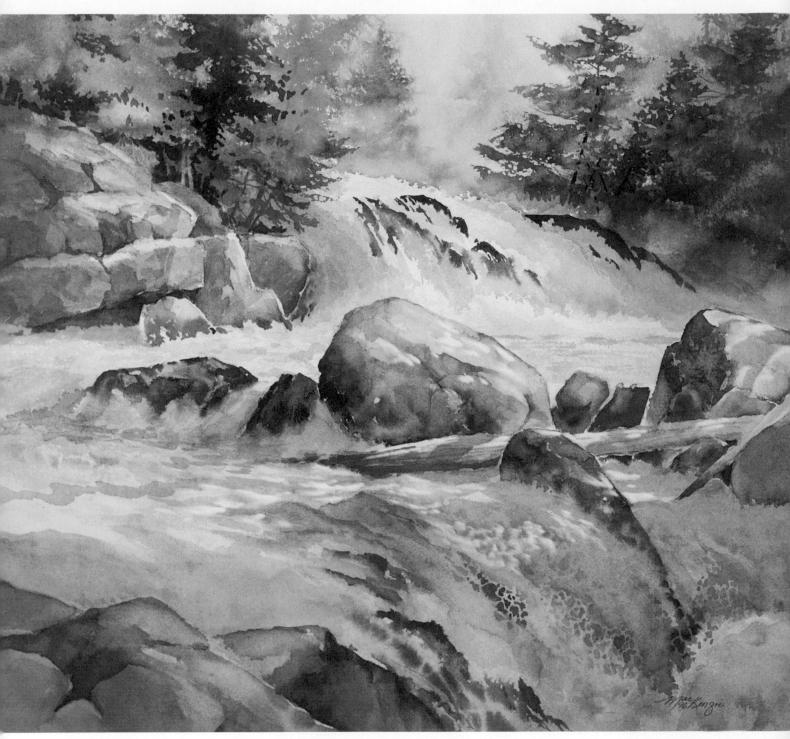

RENEWAL
Watercolor on 300 lb. Arches medium cold-press paper,
19" x 22" (48cm x 56cm)
Collection of the artist
Photographer: Kevin Dobie, Kevanna Studios

INTRODUCTION

Who you are and what you treasure most are found within you. As an artist your work is a visible means of reflecting those personal values and feelings through images of a particular place, experience or vision. No matter what level of technical virtuosity is applied, the primary objective of a true artist is always to go beyond a literal translation of the subject and communicate something that speaks of his or her unique inner self. Watercolors are an excellent vehicle for that expression.

However, a word of caution: Watercolors are not for the faint-of-heart but for those willing to explore and experiment, knowing that they risk failure, knowing that each piece of paper will not end as a "masterpiece." Nor are they recommended for those who are unwilling to relinquish the role of "master" so that they can become, instead, a "partner" in the process.

In this medium you must be willing to play the role of both patient director and alert stagehand, while the pigment and water are free to perform their magic. Try to push this medium around, and it quickly loses it charm, its transparent radiance and its life. If you already paint with watercolor then you probably know how important it is to remain open to its whimsical nature and the momentary opportunities that it offers along the way. Watercolor is a medium of countless options but few second chances.

Having said this, I should also mention the rewards of working with watercolor, chief among them being its depth. So long as you remain open to its nature, this medium will entertain you for a lifetime. There seems no end to what you can learn from and about watercolors. Those who have spent decades with it can testify how they are continually charmed and amazed by new discoveries every time they put paint to paper.

This is a medium designed to push you to your limits. So long as you keep rising to its challenges, it will keep opening doors on others. In time watercolor will become a reflection of you and your personality. Not only are your physical skills displayed, but also the style and vitality of your inner growth.

This book is based on the handouts I've produced over the years to meet the needs of students in numerous watercolor workshops. These materials were developed to clarify and simplify various aspects of the painting process, while at the same time challenging students with new possibilities. However, unlike a book of rules that tend to close our minds, this is a collection of principles, concepts and general information designed to expand the creative process. As you will see, much of this material is based on common sense, visual perception and your own innate sense of design. You will find here the basic information on tools, techniques and composition that will serve you well as either a reference or a basic foundation for your watercolor painting process.

One last thought before you begin your journey through this book: In my workshops it never fails to amaze me how people will travel great distances, pay out hard-earned cash for materials and instruction, and put up with crowded conditions just so they can study the effects of drying water. Along with a little pigment and manipulation, that's about all that's happening with watercolor. Think about it. This, the simplest of nature's processes, has been the catalyst that has filled us with wonder and challenged our imagination and ingenuity for many years. The results have been some of the most stunning expressions of mankind's creativity ever. This book is your invitation to join the magic world of watercolor.

$\boxed{1}$ Tools of the Trade

Selecting proper tools and materials for watercolors has a profound effect on the results you get. Notice that I said "proper," not "most expensive." There is a difference between buying the most expensive supplies and purchasing appropriate supplies that perform to the highest level, suit your needs and fit your budget. For example, not all paint brands cost the same. However, some colors can be of equal quality—see pages 14–17. On the other hand, buying cheap paper is only false economy. These are the kinds of things I will discuss in this part of the book, to prepare you for the next time you head for the art store. By the way, while you are out, you may want to stop at the hardware store. You will need some utility sponges and packing tape as well. What you will need for watercolors is often found in unusual places.

Watercolors

Watercolors come in tubes, cakes (pans), liquid and pencils. I discuss tube paints in this book.

Watercolors consist of finely ground pigments mixed with gum arabic, glycerin and a wetting agent. The gum arabic and glycerin allow the pigments to adhere smoothly to the paper when being thinned with water, while the wetting agent makes the paint flow evenly when diluted.

It's easy to become confused with terminology when buying watercolors. One hears about staining and nonstaining colors and wonders what the importance is. We wonder why so-called "transparent watercolors" are actually opaque. Are unsaturated colors better for a painting than saturated? From where did those fugitive colors escape, and who is chasing them anyway? Add to this the exotic manufacturer names used for colors, and it's no wonder there is confusion.

Following are the terms used in describing any watercolor paint. Understanding these characteristics is important to the results you will get.

CHOOSE COLORS WISELY

Buy new colors based on their characteristics. You will be building a palette of better quality paints that have come from a variety of manufacturers. Since mixing is the name of the game, you do not have to buy every color offered. You can mix most of what you need from surprisingly few basic primary colors. Warm and cool versions of each of the primaries—red, yellow and blue—plus a few unsaturated colors are all you need. See "Setting Up Your Palette" on page 96.

TRANSPARENT, SEMITRANSPARENT OR OPAQUE

The amount of light that passes through a color, bounces off the white paper below and reflects back to the viewer's eye determines the color's luminosity (appearance of a glow under its surface). You can see the white of the paper through transparent colors. The more nearly opaque a color is, the less luminous the results, because opaque colors do not allow light to pass through them. Thinning an opaque color with water can make it more transparent, but then it loses its intensity. If you plan to build layers of paint to achieve a desired color effect, it may be best to use transparent and semitransparent colors.

STAINING, LOW-STAINING OR NONSTAINING

This characteristic has a bearing on some techniques you may wish to perform. For example, if you wish to lift paint by scrubbing, it would be wise to use a nonstaining color.

On the other hand, if you wish to have color show through when you push paint back with a knife, lift it with a brush or use salt; then use a stainer.

SATURATED OR UNSATURATED

The term *saturated* refers to the degree of vividness of a hue. Saturated colors are those closest to the pure colors in the spectrum (see the color wheel on page 95), for example, Cobalt Blue, Cadmium Red and Lemon Yellow.

Unsaturated colors are those not found on the color wheel but that are nevertheless useful—for example, Burnt Sienna, Raw Umber and Indigo. If a color is not seen in a rainbow, it is unsaturated.

PERMANENT OR FUGITIVE

The durability of a pigment is irrelevant if you are producing something with a short life span, such as a poster, newspaper advertisement or magazine. However, in watercolors we want pigments that will survive beyond our own life span. Stable colors will not deteriorate over time under normal conditions of light and humidity. Fugitive colors will deteriorate (fade, darken or shift color) because their pigments are not chemically stable. There is no need to use fugitive colors when permanent alternatives exist. Since there are still unreliable colors on the market, you have to be on guard when you select colors. The chart "Summary of Paint Characteristics and Quality" on pages 14–15 indicates reliable colors.

FLOW

Flow is the degree to which a pigment moves on a wet surface. Flow depends on the type of pigment used (organic, mineral, chemical or dye), how finely it is ground (manufacturing process) and whether or not the paint contains fillers or neutrals (e.g., white and black). White, as an additive, will slow a pigment to a crawl. Generally the more transparent a pigment, the better it flows. Only experimentation will tell you what your paints will do.

Flow is important when you want colors to "explode" on your paper or you wish to fade out an edge of a painted area (see page 46)—for example, painting fog.

PAINT CHARACTERISTIC GROUPS

A color's staining ability and degree of transparency most greatly influence the results you get. Please remember that the characteristics of the colors shown here may vary by manufacturer. Note that groups 1 to 4 contain saturated colors.

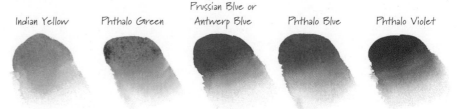

Indian Yellow | Phthalo Green | Prussian Blue or Antwerp Blue | Phthalo Blue | Phthalo Violet

GROUP 1—STAINING, TRANSPARENT COLORS

Pigments are bold and intense. They can easily overpower other nonstaining colors when mixed. They have maximum flow but are hard to move once set. They are good for layering and glazing (laying down a transparent layer of paint over an underpainting). Because they are transparent, they will not produce mud when mixed with other transparent colors. Mixed full strength, they produce rich colorful darks. Salt and water blossoms leave a stained mark.

GROUP 2—NONSTAINING, TRANSPARENT COLORS

Pigments are delicate and wipe back easily. Their transparency makes them excellent for glazing, layering and mixing of transparent grays from the primaries. Salt and water blossoms leave white marks. Flow is good.

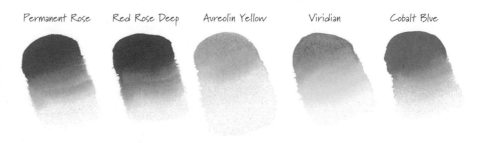

Permanent Rose | Red Rose Deep | Aureolin Yellow | Viridian | Cobalt Blue

GROUP 3—LOW-STAINING, TRANSPARENT TO SEMITRANSPARENT COLORS

Pigment intensity is average. Wiping back, scraping, salt and water blossoms work well but leave a slightly stained mark. Flow is average.

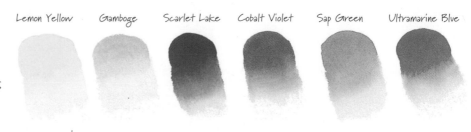

Lemon Yellow | Gamboge | Scarlet Lake | Cobalt Violet | Sap Green | Ultramarine Blue

GROUP 4—LOW-STAINING, SEMIOPAQUE COLORS

Pigment intensity is average. These colors are most luminous in washed or diluted form. However, opaque colors can create mud if they are overmixed with too many other colors. Wiping back, scraping, salt and water blossoms work well but may leave slight color. These colors have the lowest rate of flow.

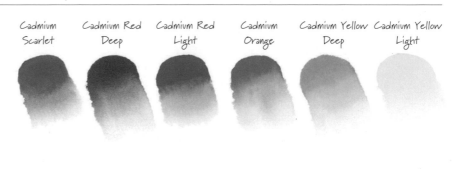

Cadmium Scarlet | Cadmium Red Deep | Cadmium Red Light | Cadmium Orange | Cadmium Yellow Deep | Cadmium Yellow Light

GROUP 5—UNSATURATED COLORS, MOSTLY LOW-STAINING, TRANSPARENT TO OPAQUE COLORS

Pigments have low intensity. Warm colors are usually earth oxide based. Low-Staining of most colors allows for easy wipe back, water blossoms and scraping. Blackened colors often stain. Opaque and semiopaque colors always have the danger of adding muddiness to a mixture. Flow varies.

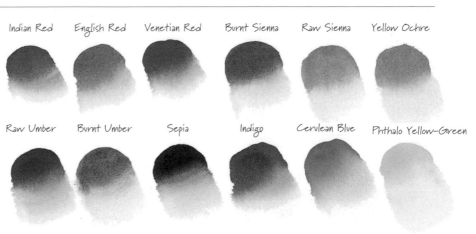

Indian Red | English Red | Venetian Red | Burnt Sienna | Raw Sienna | Yellow Ochre

Raw Umber | Burnt Umber | Sepia | Indigo | Cerulean Blue | Phthalo Yellow-Green

DIFFERENCES BETWEEN PAINTS

Those paint manufacturers with vested interests like to tell artists that one brand of paint will not mix well with another, or, for best results, you should stick to only one brand, preferably theirs. This is nothing but hogwash. This is like saying that we should eat only one brand of food because if we mix brands it might make us sick. The pigments are the same no matter who uses them to make paint. Differences arise in how much pigment a manufacturer uses, how well it's processed, and the type of binders and fillers added. These factors will influence individual performance but not compatibility between brands.

SUMMARY OF PAINT CHARACTERISTICS AND QUALITY
according to ASTM standards

CHARACTERISTICS

HUE	TEMP	TRADE NAME	transparent	semitransparent	opaque	staining	low-staining
yellow	COOL	Cadmium Yellow Light (Pale, Lemon)			●		●
	COOL	Yellow (Hansa)			●		●
	MED	Aureolin	●				●
	MED	Indian Yellow	●			●	
orange	WARM	Cadmium Yellow Deep			●		●
	WARM	Gamboge			●		●
	VARIES	Cadmium Orange			●		●
red	WARM	Cadmium Red Light (Pale)			●		varies
	WARM	Cadmium Red			●		●
	WARM	Cadmium Red Deep			●		●
	MED	Cadmium Scarlet, Scarlet Lake			●		●
	COOL	PV 19- (Phthalo Crimson, Phthalo Red, Ruby Red, Red Rose Deep, Quinacridone, Permanent Rose)	●				●
violet	COOL	Cobalt Violet			●		●
	WARM	Phthalo Violet, Permanent Magenta, Bayeaux Violet	●			●	
blue	WARM	Ultramarine Blue	●				●
	MED	Cobalt Blue	●				●
	COOL	Phthalo Blue PB15 (Winsor, Intense, Helio, Hoggar, Monestial, Rembrandt, Cyanine, Hortensia, Primary)	●			●	
	COOL	Cerulean Blue			●		●
	COOL	Prussian (Antwerp, Paris)	●			●	
green	COOL	Viridian	●				●
	COOL	Phthalo Green PG7 (Winsor, Intense, Armor, Helio, Cyanine, Genuine Deep, Holbein Viridian, Monestial)	●			●	
	MED	Hooker's Green			●		●
	WARM	Sap Green			●		varies
unsaturated oxides, low-intensity colors	COOL	Indigo (Burnt Sienna + Ultramarine Blue)			●		varies
	WARM	Burnt Sienna (Dark Orange)	●				●
	WARM	Burnt Umber (Dark Yellow Brown)			●		●
	WARM	Yellow Ochre (Light Yellow Brown)			●		●
	WARM	Raw Sienna (Light Yellow Brown)		●			●
	COOL	Raw Umber (Medium Yellow Brown)			●		●
	WARM	English Red (Yellow to Violet Brown)			●		●
	WARM	Light Red (Light Reddish Brown)			●		●
	WARM	Indian Red (Reddish Brown)			●		●
	WARM	Venetian Red (Dark Reddish Brown)			●		●
	VARIES	Sepia (Black + Brown)			●		varies

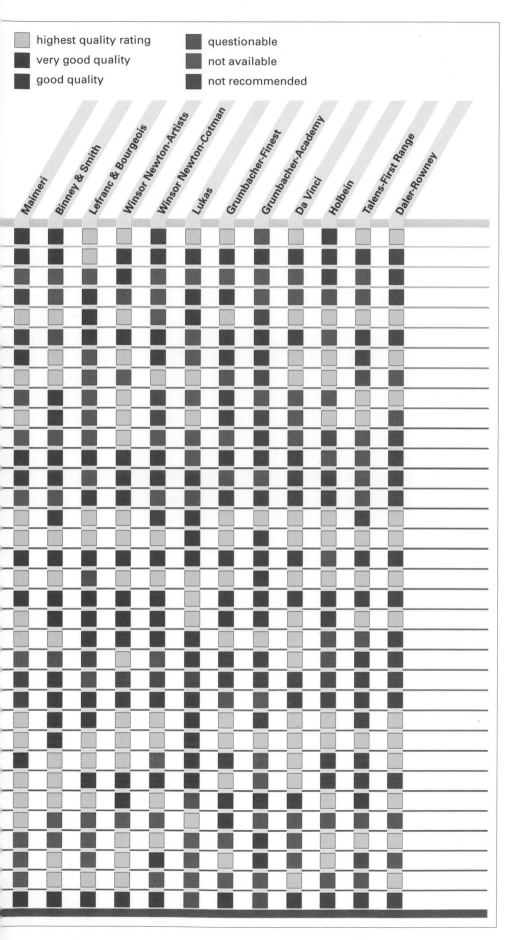

PAINT CHARACTERISTICS AND QUALITY

For your assistance, the following chart offers the characteristics and quality ratings of a range of commonly used colors. I have omitted many colors because they are unique to one manufacturer. On these pages you will also find pigment number charts that can be of value to you in finding the best quality paints.

CHECK THE LABEL

More and more people are buying their food according to the ingredients on the package and not just the brand name. We must also start looking at the ingredients or pigments used to make our paints.

Trade names for tube colors (such as Winsor Blue, Red Rose Deep or Sahara Yellow) do not tell us much about what ingredients or pigments make up the paint. Winsor Blue, Hoggar Blue, Helio Blue, Brilliant Blue and Speedball Blue all contain exactly the same pigment—Phthalocyanine Blue, or Phthalo Blue for short. Since more and more manufacturers are indicating the pigments on their labels, we should be buying our colors according to those pigments and not just the trade names.

Studies—such as *The Wilcox Guide to the Best Watercolor Paints* (Artways, 1991) and Hilary Page's *Guide to Watercolor Paints* (Watson-Guptill, 1991)—have prompted manufacturers to offer more reliable paints. By listing the pigments on their labels, either by name or number, they are trying to show that quality is also one of the ingredients.

Research shows that there are many excellent quality paints. There is no need to use inferior types. The good news is that there is usually no price difference. Look for an American Society of Testing and Materials (ASTM) rating on the label. Get to know reliable pigment names and numbers. I would go so far as to suggest using only those brands that do tell what is in the tube.

PIGMENTS BY THE NUMBERS

Each of the pigments used in the manufacture of paint has an assigned number, and it's a good thing. It's a lot easier to remember and to say "PY154" than "Benzimidazolone Yellow H3G." You don't have to remember a lot of chemical names, just the numbers that represent them. Since pigments are not all created equal, in that some are more durable or lightfast than others, we need to know which are the good guys and which are the bad. We can do this by the numbers because many manufacturers are now putting them on their labels. The chart here contains the most common pigments (by number) used in watercolor paints. If paint contains a bad pigment and a good one, the bad pigment will always reduce the quality of the paint.

HUE	PIGMENTS TO AVOID	RELIABLE PIGMENTS
yellow	PY1, PY1:1, PY24, PY34, and NY55 are the most common offenders.	PY3, PY35, PY37, PY40, PY42, PY43, PY53, PY97, PY153
orange	PO1, PO13, PO34	All other Pigment Orange numbers (i.e., PO20, PO20:1, PO36, PO43, PO49, PO62)
red	Every Pigment Red number below 100, except PR5, PR6, PR7, PR9, PR48:4 and PR88MRS	Every Pigment Red number above 100, except PR105, PR106, PR112, PR122, PR146, PR173, PR177, PR181
violet	PV1, PV2, PV3, PV4, PV5:1 PV23BS, PV23RS, PV39	All other Pigment Violet numbers (i.e., PV14, PV15, PV16, PV19, PV46, PV49)
blue	PB1, PB24, PB66	All other Pigment Blue numbers (i.e., PB15, PB15:1, PG17, PB27, PB28, PB29, PB33, PB35, PB36, PB60)
green	PG1, PG2, PG8, PG12	All other Pigment Green numbers (i.e., PG7, PG10, PG17, PG18, PG19, PG23, PG36, PG50)
brown	NBr8, PBr8, PBr24	All other Pigment Brown numbers (i.e., PBr6, PBr7)

RELIABLE OR UNRELIABLE?
Unfortunately some watercolors still contain unreliable pigments. Fortunately more and more manufacturers are putting pigment numbers on their labels.

TRADE NAME	OFFENDING PIGMENTS That Would Compromise Paint Quality			
Alizarin Crimson, **Alizarin Madder,** **Madder Lake,** **Rose Madder,** **Brown Madder,** **Carmine or any other** **combination of these names**	NR4- NR9- PR83- PR83:1- PR181-	Carmine Natural Red Rose Madder Natural Red Rose Madder Alizarin Alizarin Crimson Thioindigoid Magenta	PR83:1- PR106- PO34- PY1-	Alizarin Crimson Vermilion Dairylide Orange Arylide Yellow
Crimson Lake, **Scarlet,** **Vermilion or any other** **combination of these names**	PR4- PR23- PR48:1- PR48:2- PR48:4-	Chlorinated Para Red Naphthol Red Permanent Red 2B (barium) Permanent Red 2B (calcium) Permanent Red 2B (manganese)		
Van Dyke Brown	NBr8-	Van Dyke Brown		
Chrome Yellow	PY34-	Chrome Yellow Lemon		
Gamboge	PY1- NY24-	Arylide Yellow Gamboge	PO1-	Hansa Orange
Hooker's Green or Sap Green	PG8- PG12-	Hooker's Green Green	PY1- PY100-	Arylide Yellow Tartrazine Lake

UNRELIABLE PIGMENTS

Do your favorite colors contain unreliable pigments? Here are the pigments that could jeopardize the quality of some common colors.

COLORS TO WATCH OUT FOR

The popular colors above have earned red flags beside their names because they often contain fugitive pigments. This is not to say that all makes of paint that carry these names are undesirable. Because of the popularity of many of these colors and the desire to produce a quality product, some manufacturers now produce them with more durable pigments. Only the ones containing the indicated pigments have questionable durability. Read the labels.

Brushes

Whether made from natural fibers, synthetic fibers or a blend, your brush is a major factor in the success you have with watercolors.

However, if you are like most people, you might find the array of brushes available in art supply stores a bit baffling. Many artists have purchased brushes that they have not yet figured out uses for, and many have bought brushes that did not meet expectations.

As a rule, the performance of a brush matches the price you pay for it, but remember that the price range varies with the type of bristle used. A cheap sable is still far more expensive than a top-of-the-line hog hair. The purpose of this section is to explain the basic characteristics of brushes so you can make a more informed choice the next time you are in the market for one.

RECOMMENDED BRUSH TYPES AND SIZES

As with any tool, you select your brushes according to the jobs you want them to perform. For a particular painting, we select our brushes according to how we want to handle each area or phase of the work. Each function requires a different brush, and the right brush, if you hope to achieve the desired results. Every artist has his or her own selection of favorite brushes, and you will undoubtedly develop your own. Here are some basic types that will allow you to perform a wide range of painting functions.

NATURAL BRISTLE OR HAIR BRUSHES

Down through history, humans have made brushes from all types of plant and animal fiber. Fur or hair has won the popularity contest (unfortunately for the animals). Each type of

¾-INCH FLAT STROKE BRUSH
In a synthetic or synthetic mix, this brush has extra-long bristles that add great flexibility and range of use.

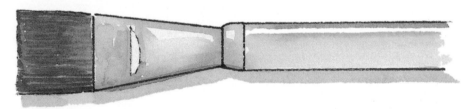

RIGGER OR SCRIPT BRUSHES
These have long, thin bristles, synthetic or blend, that come to a point. They come in various sizes. Similar small stroke brushes have a squared end. They produce fine lines of consistent width.

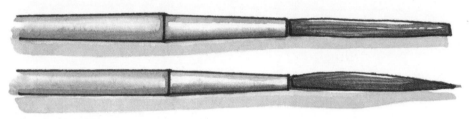

1-INCH SYNTHETIC FLAT
Look for brushes with bristles that have snap. Though the brush shown here does not carry much paint, the beveled clear acrylic handle makes sharp-edged strokes. When your paint is still damp, you can use the edge of the handle to remove paint and make fine lines. This brush is also good for drybrushing, wood grain, fabric, etc.

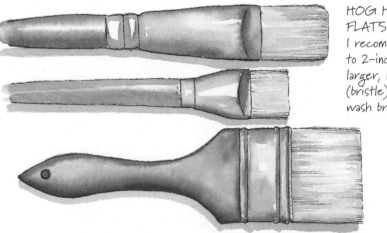

HOG HAIR FLATS
I recommend ¾- to 2-inch, or larger, hog hair (bristle) flat, stiff wash brushes.

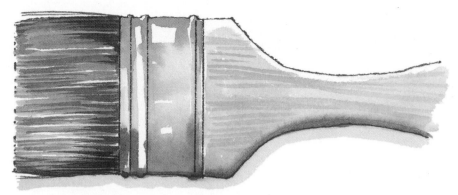

1½- TO 2-INCH OX HAIR WASH BRUSH
Very springy, this brush carries a great load of paint. It is not as rough as a hog hair brush.

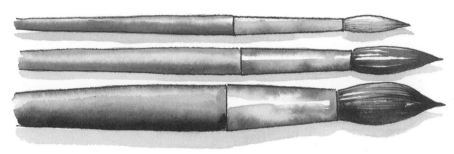

ROUNDS
I recommend nos. 4, 6, 8, 10 and 14 rounds made from sable, synthetic or a synthetic and natural blend. It is wise to have a selection of these all-purpose brushes.

1½-INCH TO 2-INCH SYNTHETIC WASH BRUSH
Bristles may be white to red-brown, depending on the type of fiber used. They have excellent handling qualities. They make a very precise, hard-edged stroke that is great for positive and negative painting.

fiber produces a brush with a unique feel and handling characteristics.

The factors setting natural brushes apart from synthetic brushes are their overall durability, their ability to hold a lot of liquid, and their ability to release that liquid slowly and evenly. These features are due, in no small part, to the tapered ends of natural hairs. In some cases, natural hairs are also "flagged" (split ends).

Natural bristles vary greatly in their stiffness, particularly when wet. *Snap* is a brush's ability to spring back to its original shape when wet. Most painters favor brushes with snap, because they give far better control than brushes that bend and remain bent. However, it is not a matter of finding the stiffest brush. What most artists want is a brush with a combination of snap and flexibility, a blend of smoothness and sensitivity that makes the application of paint an effortless process.

KOLINSKY RED SABLE
Kolinsky red sable is the most valuable soft-brush hair, characterized by its strength, thickness, spring and fine point. The hair comes from the tails of Siberian martens (mammals related to the weasel).

RED AND PURE SABLE
Red and pure *sable* brushes are not as fine or springy as *kolinsky*, nor as expensive, but they make fine watercolor brushes. Hair comes from Asian (and probably North American) red martens.

OX HAIR
Often used in blends, *ox hair* bristles have strength and springiness and hold a fine point, but they cannot compare with red sable. Ox hair brushes range in color from white to black.

SABELINE
Made from the finest ox hairs dyed to resemble red sable, *sabeline* brushes are less expensive than sable, but sabeline produces only a mediocre brush.

CAMEL HAIR
Camel hair is a trade term that refers to a whole range of hairs that vary greatly in softness and performance. It could be squirrel, goat, pony, bear, sheep, monkey, etc., or a blend of these—whatever happens to be lying around, which is a good reason to avoid these brushes.

BADGER
Often used in blends, particularly in flat brushes, *badger hair* strikes a

good balance between the softness of red sable and the resilience of China bristle.

GOAT HAIR

Goat hair bristle is common in oriental brushes called hakes. They are very soft and hold a lot of liquid but lack the snap and control of a China (Hog) bristle, which it is often mistaken for.

HOG (CHINA) BRISTLE

The bristles of these brushes range in color from pure white to tan. They are stiff, have the capacity to carry a good amount of paint and water, and are relatively low cost. The white to platinum blonde bristles—called China bristles—are the best.

Hog bristle brushes are real workhorses that can scrub up color, and yet, by using the side of the brush, you can produce wonderfully loose, irregular marks that other brushes cannot imitate. The bristles are stiff when dry but develop a suppleness when wet. Be aware, however, that there is a tremendous range in the quality (and price) of hog hair brushes

The word *bristle* is a broad reference to any type of fiber used to make the hairy end of your brush—for example, "My brush has synthetic bristles." However, *bristle* can also refer to brushes made from hog or boar hair. Do not buy the black ones that some dealers call "bristle brushes." They are invariably coarse synthetic types that do not work well. See "Painting With Brushes" on page 33.

Unfortunately, good flat hog hair *wash* brushes are not always that easy to find. Art stores do not usually put them with watercolor brushes, but either by themselves, as gesso or mural brushes, or acrylic brushes (large flat acrylic brushes with hog bristles are excellent for watercolor).

You can tell if you are buying a good hog hair brush by spreading the bristles apart and looking

between them. If you can see the wood of the handle, do not buy the brush. On the other hand, if you see solid bristles, chances are you have a good one. The diagram here illustrates how the construction of hog hair brushes (and some cheaper synthetic wash brushes) influences their performance.

If you cannot find hog hair brushes in your art supply store, try your craft, hardware, building supply and cookware stores as well. These brushes show up in the oddest places and as many things, such as student tempera paint brushes, disposable paint and varnish brushes, basting brushes, etc.

Do not confuse hog or boar bristle brushes with *hake* brushes. Hake brushes are also flat blonde-colored brushes. The hake is a fine natural-fiber (goat) brush but lacks the snap of a hog hair. Beware of the cheap disposable types with inferior construction and poorly assembled bristles that look like a witch's broom when wet.

SYNTHETIC BRISTLES

Synthetic brushes have become very popular because of their price and handling ability, but we must remember that these also can vary in performance, depending on the construction and quality of filament used. Synthetic brushes usually have good snap and fine points, which give the artist a fair amount of satisfaction and control. However, the major drawback to pure synthetic brushes has always been their inability to hold as much liquid and release it as consistently as the natural fibers. The smoothness of the bristle surface

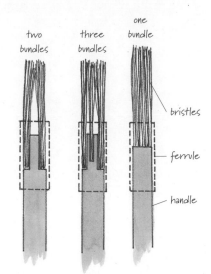

If you can see the wooden handle when you spread the bristles, it's a sign of inferior construction. Do not buy it.

Side view of handle

CONSTRUCTION OF HOG HAIR WASH BRUSHES

The cheaper, most inferior types have two and sometimes three separate bundles of bristles fastened to the side and middle of the handle. These brushes look fine until wet, when individual bundles of hairs separate, making painting almost impossible. A single bundle of bristles at the butt end of the handle makes the best brush, with all bristles held with glue and a ferrule (the part of a brush holding the hairs or bristles).

and the lack of taper in the fiber allow the liquid to slide off synthetics more readily than natural fibers. Manufacturers have developed finer, more tapered or flagged fibers.

Synthetic fibers also tend to break more easily than natural types. The result is that your synthetic brushes, particularly rounds, may lose their point faster than an equivalent natural brush, particularly if you do a lot of rough brush work. You can also lose the tip on your synthetic brush by jamming it onto the bottom of your water container when cleaning it. It's best to clean one of these brushes by rolling it on the inside of the water container.

Paper

Choosing cheap paper is a big mistake. Many students try new techniques with the best brushes and most expensive paint, only to fail because they are working on cheap paper. Unfortunately, they think it's their fault that they cannot carry off the procedure, when it's the paper that will not let them. You need all the help you can get, and your paper is one material that will give you that help.

You can buy watercolor paper by the sheet, roll or block (not to be confused with the pad). The cheapest and most versatile way to buy paper is in sheets since you can cut them to whatever size you wish and mount them on a board for painting. A watercolor block is similar to a pad, but it is bound on all four sides, except for a few unbound inches where you can slip a knife under the paper to remove the top sheet. A watercolor block may be more expensive than sheets, but it does not require mounting, because it has a sturdy backing board. However, a painting done on a block must be dry before you can expose the next sheet for another painting. This might be a problem if you do not finish with the first painting before you want to start a second.

THE BEST PAPER

The best watercolor papers contain 100% rag (cotton) fiber with a neutral pH of 7 (acid free) and are handmade or mouldmade. Paper containing 100% rag does not guarantee a neutral pH. Make sure your paper is acid free, because acid-free papers resist yellowing and deterioration over time. Some papers made in an acid environment are buffered with alkaline salts to obtain a neutral pH.

HANDMADE PAPER

Handmade paper is made with a mould (a screen that filters fibers through it) and deckle (a frame resting on or hinged to the edges of the mould that defines the edges of the sheet). A deckled edge is the natural, fuzzy edge of handmade papers. Handmade papers have four deckled edges.

MOULDMADE PAPER

Made by a slowly rotating machine called a cylinder mould, mouldmade paper looks like handmade, but usually has only two deckled edges. Mouldmade paper gets its strength from a beating process that interlocks the fibers from front to back into a single layer.

MACHINE-MADE PAPER

Machine-made paper has a uniform surface texture and size. Watercolor pads are most often machine made. Machine-made papers may contain the same quality fibers and neutral pH as handmade or mouldmade papers, but the fibers end up in layers. Try separating the edge of a piece of handmade or mouldmade paper and then a machine-made paper, and you will see what I mean. No matter how heavy it is, machine-made paper will not take the scrubbing, scraping, taping, masking and general abuse that a mouldmade piece will.

LIFE'S TOO SHORT TO PAINT ON CHEAP PAPER

When purchasing supplies, do not buy the cheap stuff just because you are a beginner.

PAPER TEXTURE

Watercolor paper comes in hot-press, cold-press and rough textures. Hot-press paper has a very smooth surface that is good for detail, but paint tends to slide around the surface for a unique effect. Cold-press paper has a medium-textured finish. It is the most popular choice because paint spreads evenly, and the surface allows reasonable detail. Rough paper has a heavily textured surface that is good for loose textural effects, but not for fine detail. All are well worth trying.

DIFFERENT SURFACES
The same subject painted on hot press (top), cold press (center) and rough (bottom) illustrates the effect that paper texture has on the end product.

PAPER WEIGHT

Paper also comes in different weights, which refers to how much a ream (500 sheets) of 22″ x 30″ (56cm x 76cm) paper weighs. Heavier paper absorbs more water, stays wet longer and buckles less when wet than lighter papers do. If you are pragmatic, you will also realize that the heavier paper will allow you to paint on both sides (in case you fluff the first side). The weight of a paper has nothing to do with its quality, though it does affect how much water it absorbs.

Some light papers stand up against extensive reworking and paint removal, while some heavy weights tolerate very little. If durability under scrubbing, masking, taping or scraping is your priority, try papers made by Arches, Waterford or T.H. Saunders. If it is your style to work only with brush techniques, try softer papers made by Strathmore, Winsor & Newton or Bockingford. Bockingford, made from cellulose fibers, has exceptional wiping back strength. It is ultimately up to you to find the paper type and weight that best suits your needs.

WHAT YOU NEED

Watercolor paper
Container of water large
 enough to immerse your paper
Rigid, waterproof board
Sponge
One of the following to hold
 your paper in place:
 • Brown gummed paper
 • tape, ½-inch wide or
 wider
 • Thumbtacks
 • Staples

COMMON PAPER WEIGHTS

Inexpensive to work on, 90-lb. (190gm) paper's drawback is a tendency to buckle. When anything larger than an eighth of a sheet is used, the paper should be stretched first or wet on both sides.

A popular weight for many is 140-lb. (300gm) paper. You can work on anything less than a quarter sheet without stretching. Just tape it to a board and go.

The easiest and most versatile to work with is 300-lb. (640gm) paper. Minimum buckling means it rarely needs stretching.

STEP BY STEP: STRETCHING PAPER

Stretching large pieces of light- and medium-weight papers before use prevents the annoyance of buckling. The other advantage is that you can use lighter weight paper, which is much cheaper, for large paintings. It takes about two hours for a stretched piece of paper to dry, so do it well in advance of your painting session and do several at a time.

The stretching process is quite simple, but it takes time. Soak your paper so it expands, then fasten it to a board. As it dries and shrinks, it will become taut and flat. The stretched paper will not buckle when you re-wet it for painting.

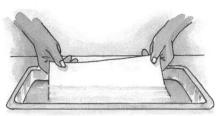

1. IMMERSE PAPER COMPLETELY IN WATER.
Let soak from thirty minutes to two hours, depending on its weight.

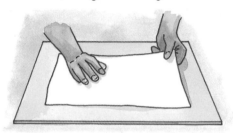

2. REMOVE PAPER FROM THE WATER.
Shake off excess water and place on a rigid, waterproofed board such as plywood or Masonite.

3. SMOOTH AND REMOVE EXCESS WATER WITH A DAMP SPONGE.
Slightly dry the edges with a folded paper towel.

4. MOUNT YOUR PAPER.
Cut four lengths of brown gummed paper tape, and dampen each with the sponge just before applying. Do not over-wet the tape. A ½-inch (1cm) width should do for most applications. Use heavier and wider tape for large, heavy papers. Overlap the edges of the paper by about ½ inch (1cm) and press down firmly. Cut off excess tape and stand the board upright to dry slowly.

Palettes

Few beginning painters realize the subtle influence that their choice of palette has on the way they paint. A palette is more than just a place to store and mix paint. Your palette is where you coordinate your color strategy. A complicated arrangement of colors on your palette is not necessary. You only need a logical arrangement that allows you to find and mix colors with ease. A disorganized palette also can influence your spontaneity and confidence as you paint.

ARRANGING YOUR COLORS
Some artists like to lay out their colors in the order of the color wheel, with the primary colors occupying three sides and unsaturated colors the fourth. Some artists like a progression of warm colors on one side and cool colors on the other. Others like to separate staining colors from nonstaining colors, transparent colors from opaque. Like every other artist, you must find an arrangement that has a logic that works for you. It is worth noting that the fewer the colors, the simpler the logic required.

Regardless of your layout, remember color juxtaposition. The best way to arrange your colors on your palette is in spectrum (or color wheel—see page 95) order. That way, if one color accidentally spills into the next, the result is less damaging than if the colors were greatly different or complementary (opposite each other on the color wheel). Keep this in mind when devising your layout. See "Selecting and Setting Up Your Palette" on page 97.

YOUR PALETTE'S PHYSICAL CHARACTERISTICS
The way you lay out colors on your palette influences how quickly you can find what you need. The physical characteristics of the palette determine how easily you access your colors.

Many commercial palettes have tiny, deep color wells that are completely incompatible with large brushes. It's hard to be spontaneous with your big brushes if you cannot reach the paint. A large white platter would serve you better. I have even used clean Styrofoam meat trays. White enameled steel meat trays are ideal. I have made divisions for colors and mixing in mine with white silicone bathtub caulking (see page 25). The tray slips into a plastic bag for transporting. In my studio I use a similar palette made from a large piece of white arborite (e.g., Formica and melamine) originally cut out for the sink hole in my countertop. I squared it up on a saw, added an edge and made similar divisions with caulking.

A major advantage these palettes have over most commercial types is that the color wells are flat. This may seem insignificant, but the slanted wells on most palettes allow dirty pigment to run back over your clean paint. With a flat well, the dirty paint remains well below the lump of clean pigment, allowing you to access pure color from the top at any time. There are flat palettes on the market, but you have to look hard to find one with large wells. I have seen people make their palettes from white enamel trays from stoves and refrigerators that they picked up at garage sales. I have even seen artists use plastic serving trays bought in the housewares department of a store. You will find information on making your own custom palette on the next pages.

PALETTE WELL SHAPES

The shape of the color wells on your palette seriously influences the cleanliness of your colors. Sloped color wells allow foreign colors, carried there during mixing, to flow back and contaminate the clean resident color. Flat wells, on the other hand, allow the dirty pigments to disperse away from your lump of clean pigment.

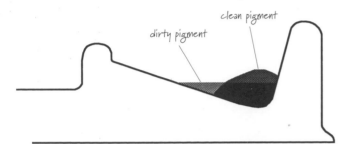

PALETTE WITH SLANTED COLOR WELLS

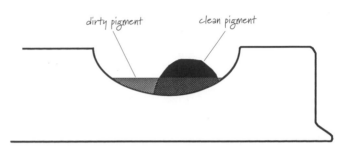

MUFFIN TIN DESIGN

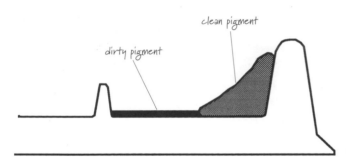

PALETTE WITH FLAT WELLS

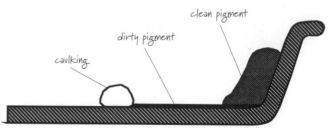

MEAT TRAY PALETTE WITH CAULKING WELL DIVIDERS

STEP BY STEP: DO-IT-YOURSELF PALETTE

One of the charms of working in watercolors is the opportunity it provides to be resourceful and inventive. If you cannot find what you need in an art supply store (or the price is too high), look elsewhere—other types of stores, your attic, garage sales, etc. I have obtained materials from drug or hardware stores, kitchen/housewares boutiques, and office product, photography, auto or building suppliers. You just never know where you are going to find watercolor supplies.

What you need may even be in that art supply store, but sometimes you just cannot find exactly what you need. The only answer is to take up the challenge and make it yourself. Such is the case of the palette described below. With minimal carpentry skills and tools, or a friend who has both, you can construct a studio palette that has the large wells and mixing areas you need.

The base of the palette is a piece of finished shelving found in building supply stores. This is a particleboard that has a white plastic surface on each side. It comes in 8-inch (20cm) and 12-inch (30cm) widths. Choose the width you desire, and cut off the length needed. The supplier can probably do this for you. There will be enough in one shelf to make several palettes, so why not make it a group project with some friends? You will need some material to make the edging on your palette. I have made some suggestions here.

The dimensions you need depend on the number of wells that you wish to have. They should be at least 2" x 2" (5cm x 5cm), so cut the board an even number of inches in length. I have shown some sample sizes here. Just because you make twenty wells does not mean that you have to put out twenty colors. It's best to allow a few empty ones for those new colors that always come along. See "Setting Up Your Palette" on page 97.

Remember that this new palette with its big wells will be for naught if you continue to put only a smidgen of paint in each well. Big brushes require a good lump of paint.

See "Setting Up Your Palette" on page 97.

WHAT YOU NEED

8-inch or 12-inch-wide white particleboard shelving (palette base) in the length you want, depending on the number of 2" x 2" wells you wish to have

Edge molding that extends ¾ inch above the top of the base

Varnish for wood molding

Something to attach molding to the edge of your palette base, such as wood glue and nails or drill and screws

Well-ventilated working area

Tube of caulking

Scissors to cut the end of the caulking tube

Ruler

Pencil

Popsicle stick

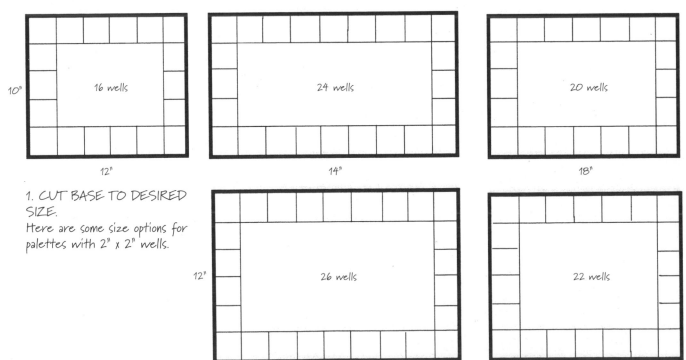

16 wells — 10" × 12"

24 wells — 14"

20 wells — 18"

26 wells — 12"

22 wells

1. CUT BASE TO DESIRED SIZE.
Here are some size options for palettes with 2" x 2" wells.

doorstop molding

a strip of the shelving material

custom cut

fancy molding

metal angle

metal stair nosing

2. CHOOSE EDGE MOLDING.

The edging you choose is up to you. I have suggested some types of edging here. The only criterion is that it must extend about 3/4 inch (2cm) above the top of the base.

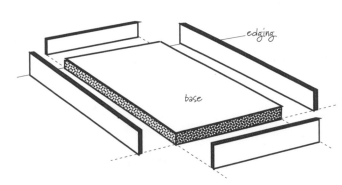
edging

base

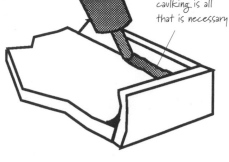
A fine bead of caulking is all that is necessary

3. ATTACH MOLDING TO BASE.

When cutting edging to length, don't forget to allow for overlapping or mitering of the corners. You may wish to varnish any wooden edging before attaching it so it won't absorb moisture and paint. Attach the molding to the edge of your palette. If the molding is wood, use glue and nails to attach it. If you choose metal, drill and attach with screws.

4. CAULK INSIDE JOINTS.

After the edging is on, run a small bead of caulking along the inside joints to keep your paint from getting away on you.

Apply caulking in a well-ventilated area. Cut the end of the tube of caulking straight across. Do not cut it at an angle as you would for most caulking jobs. Let the caulking dry.

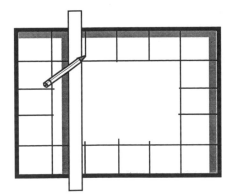

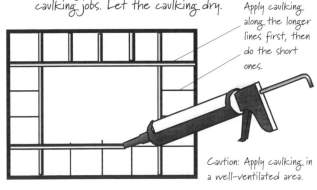
Apply caulking along the longer lines first, then do the short ones.

Caution: Apply caulking in a well-ventilated area.

5. LAY OUT WELLS WITH RULER AND PENCIL.

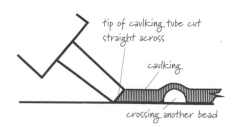
tip of caulking tube cut straight across

caulking

crossing another bead

6. APPLY CAULKING ALONG WELL LINES.

Try to keep the tip of the nozzle touching the palette as you maintain a steady flow. Lift it only to cross over other beads. For the short beads, start at the edging and move toward the center. Let the caulking dry at least twenty-four hours before adding paint.

Don't expect perfection! This is tricky stuff. This could be one of the biggest messes you ever get yourself into if you start touching the caulking with your fingers. You will more than likely get less than perfect beads and tails at the end of each run. You can smooth these out a bit with a very wet Popsicle stick. Don't worry about appearances. When you start painting with your new palette, you won't even notice.

Palette Knives

Many artists scrape back damp paint with a palette knife to leave light marks, but you can also use a palette knife to apply paint if the knife is clean and of sufficient stiffness (see "Painting With a Palette Knife," page 38). The most common palette knife is made of metal, but there are nylon types on the market that also work well. Regardless, choose one that is very stiff. A knife with an offset handle will make it easier to access the paint.

STEP BY STEP: CLEANING YOUR PALETTE KNIFE

The knife must be absolutely clean before it will hold paint. To clean it, use a small piece of 240- to 400-grit wet-or-dry sandpaper (sometimes called waterproof sandpaper). This superfine sandpaper can be found in most hardware stores. It is usually a dark gray color on a green paper backing. Use it with water, which acts as a lubricant when cleaning the knife.

WHAT YOU NEED

Palette knife
Superfine (240- to 400-grit) wet-or-dry sandpaper for sanding
Water
Edge of table

PALETTE KNIVES SHOULD BE STIFF
You can paint with almost any type of palette knife so long as it's stiff.

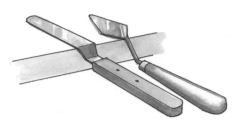

1. HOLD BLADE BOTTOM-SIDE UP ON EDGE OF TABLE.
Because it is more efficient to rub the paper on the knife than the knife on the paper, start by holding the blade bottom-side up on the edge of a table. It is not necessary to clean the top side of the blade.

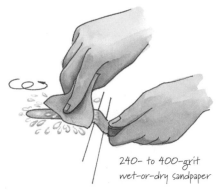

240- to 400-grit wet-or-dry sandpaper

2. SCRUB BLADE WITH 240- TO 400-GRIT WET-OR-DRY SANDPAPER.
Dip a small piece of sandpaper in water, and immediately start scrubbing the surface of the blade in a gentle, circular motion. You may have to keep re-wetting the paper and scrubbing harder to remove any dried oil paint. New knives have a clear coating of varnish that you must remove. Once you have cleaned your knife, it doesn't take much to freshen the surface when needed.

You can tell if the knife is clean by dipping it in water. If the water clings smoothly to the blade, then it is clean. If the water beads up, then the knife is still dirty and needs more cleaning. Make sure your palette knife is clean every time you wish to paint with it.

PAINTING STICKS

When you think of it, this was probably the first painting tool (after the finger). Any type of small stick or twig that you can shape with a small utility knife will do—a dowel, tongue depressor, Popsicle stick, etc. I use tongue depressors because they split easily into long tapers. I can then sharpen the tip with a utility knife to the size I want.

Apply paint to the stick with a loaded brush. The initial charging of the stick with color may take time, because the paint must soak into the stick. After that, it is easy to apply the paint to it. The more paint that covers the stick, the longer you can make marks with it. You need to experiment with various tips until you find sizes that work for you. You can make lines of varying width with great precision with a stick. See page 39. Sticks are also great for applying masking fluid. See page 54.

Painting Sponges

This is not what you did in kindergarten, and it's not the type of painting done with a natural sea Sponge. For this you will need the synthetic cellulose type sold in hardware stores and housewares departments. These sponges come as blocks, often in bags of five or six, but do not confuse them with the synthetic foam plastic ones. The way to tell the difference is by squeezing them. The cellulose sponge, unless it has been premoistened, is firm and barely spring_ back when squeezed, whereas the plastic sponge is soft and springs back readily. The plastic sponge also has a shiny or translucent appearance, while the cellulose sponge is opaque.

STEP BY STEP: MAKING PAINTING SPONGES

For this type of sponge painting you work with a small piece of synthetic sponge that you have carefully shaped by tearing. The marks that the sponge makes are unlike those from any other tool, and yet to do it right the results should not look as if you used a sponge. It should keep the viewer guessing as to how you really did do it. However, the unique footprints of the sponge are secondary to the main reason for using it—speed.

As we know, timing is all-important to many of the techniques we use in watercolors. Using a sponge gives us an edge because it allows us to apply a lot of paint to a big area quickly. We are therefore able to perform techniques we cannot do with a brush. Once you have made your sponge as illustrated, turn to "Painting With a Sponge" on pages 40–41 for ways to use it.

WHAT YOU NEED

Synthetic cellulose sponge block
Utility knife
Water

1. IDENTIFY YOUR SPONGE'S WORKING SURFACE.
Examine your sponge block. Two sides will have more deep holes in them than the others. Use one of these faces as the working surface of the sponge you tear.

2. CUT A SLICE OF SPONGE.
Using a fully extended utility knife, carefully cut off a ½– (1cm) to ¾–inch (2cm) slice of one of the sides with deep holes. Do this when the sponge is dry.

3. TEAR YOUR SPONGE TO AN OPTIMUM "LEAF" SHAPE.
The objective now is to tear out a number of smaller sponges from this slice. This is the hard part, but wetting the sponge makes it easier to tear into smaller pieces. You will also need some fairly strong fingernails. Ideally you want to tear off little sponges pointed on each end and irregular along the sides—a rough willow leaf shape.

Start by wetting the sponge slice, then subdivide it into several smaller pieces. One slice will make several pieces, since each finished sponge will be only 2 (5cm) to 2½ inches (6cm) long. It may help if you start at one end and tear the slice lengthwise. Most sponges have a grain, and, if you are fortunate, yours will have one that runs diagonally across the slice.

Tearing diagonally produces long, tapered wedges that require only a small amount of additional tearing to achieve the desired shape. If you do not tear a tapered piece, then you will have to pick away at it until you have points on both ends.

You may have to repeatedly tear away little bits in order to achieve the shape you want. Believe me, there is a lot of room for variation, and no two sponges will come out the same.

Masking Materials

Masking is, in effect, the lazy man's way around negative painting. See pages 73-75. Instead of carefully painting around the light shapes, you cover them with some sort of masking material that protects them while you paint over the whole area. When the paint is dry, the masking material is removed to reveal the light shapes. There are several materials you can use to mask out an area in your painting, including candle wax, rubber cement, liquid latex and tape. These last two are the most common and the ones I wish to examine here.

LIQUID LATEX

This material has several names — Miskit, Frisket, White Mask, Liquid Resist, Drawing Gum, Maskoid, Grafigum, etc., depending on who makes it. It is essentially all the same material—an emulsion of natural latex, water and ammonia (preservative) and, in most cases, color. Quality varies, so you must search for one that suits your needs. Personally, I prefer Drawing Gum made by Pebeo. It covers well and its gray-blue color allows me to see clearly where I am putting it on the white paper, which white types do not.

SOME DOS AND DON'TS WHEN USING MASKING FLUID

Do test the masking material on your paper beforehand. *Don't* assume that it will work on all types of watercolor papers.

Do stir. *Don't* shake. Shaking a bottle of masking fluid puts air bubbles into the emulsion that will later break, producing pinholes where paint can leak through to your paper.

Do let masking fluid dry natural-

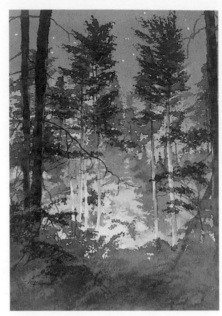

LIGHT IN THE FOREST
11" x 15" (28cm x 38cm)
Private collection

SHAPES PAINTED WITH A SPONGE
Light in the Forest makes use of both positive and negative shapes painted with a sponge. The dark, positive shapes of the background trees gradually lighten as they move downward, but they are kept dark enough to define negative space around the lightest trees near the ground. The lightest trees, in turn, contrast with the dark shrubbery in the foreground.

ly in the shade. *Don't* dry masking fluid in direct sunlight or with a hair dryer, unless you want it permanently bonded to your painting.

Do apply masking fluid to dry paper. *Don't* apply masking fluid when the surface is even slightly damp, because the paper will absorb it, making it impossible to remove.

Do wait until it is thoroughly dry before applying paint over it. *Don't* paint for at least twenty to thirty minutes.

Do remove when the paint is

thoroughly dry. *Don't* rush things, or you will smear pigment into the masked-out area.

There are many tools you can use to apply liquid masking fluid. Among these are brushes, sticks, sponges, toothbrushes for spattering, calligraphy pens, atomizers, etc. See "Masking," page 54.

MASKING WITH TAPES

Always test the tape first on the paper you intend to use. Some very expensive papers won't stand up to taping. Masking tape is not always reliable on rough-textured papers. Its thickness will not allow it to follow the undulating surface, so paint can sometimes creep in under it.

PACKING TAPE

Packing tape is a thin plastic tape that comes in big, wide rolls. It's found in hardware, department and office supply stores. Packing tape can drive you crazy because it has a mind to stick to itself and everything in sight, but it is a wonderful, inexpensive way to mask large areas and produce sharp-edged shapes. Because of its thinness, it can follow the textural surface of the paper and not let any paint get underneath it.

Buy the gray or brown-colored types of packing tape. The clear version is like white masking fluid—it's hard to see. This tape will not harm harder papers, such as Arches, if lifted gently. Test beforehand on the paper you intend to use. Warming it with a hair dryer will also ease its removal.

To mask objects with this tape, cover the shape completely with the tape and then use a very sharp single-edged razor or knife to cut around the object. So how do you keep from cutting the paper? With practice you will get a feel for how little pressure you need to put on the knife to do the job, particularly if the knife is sharp. See "Packing Tape" on page 60 for ways to use packing tape.

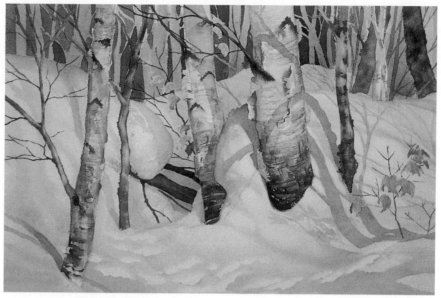

MASKING FLUID FOR TRUNKS, LEAVES AND SINKHOLES

In Afternoon Birches, I used masking fluid to save the foreground tree trunks and leaves, even though I knew that in places they would end up being darker than the snow around them. By masking, I was able to deal freely with the snow and its dark cast shadows as a unit and then turn my attention to the trunks. Notice how the masking fluid easily produces an irregular edge on a shape.

I also used masking fluid to create the sinkholes in the snow. I softened the saved white shapes on the back side of the holes to give the appearance of direct sunlight hitting them.

AFTERNOON BIRCHES
15" x 22"
(38cm x 56cm)
Private collection

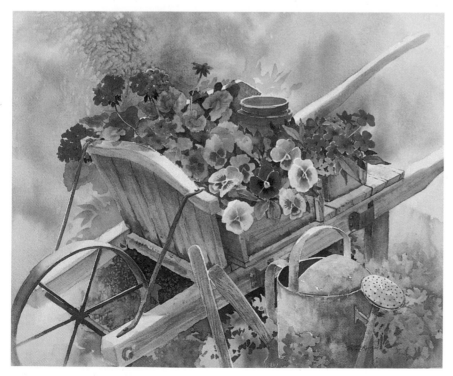

PROMISES OF SPRING
19" x 22" (48cm x 56cm)
Private collection

MASKING FLUID AND PACKING TAPE

I used the tape for the larger, straighter-edged shapes of the wheelbarrow and watering can. It was easier to handle the irregular shapes of the flowers with masking fluid. I completed the background and let it dry, then removed the tape for the wheelbarrow. I then applied liquid masking again to save the plants that were to hang over the edge of the wheelbarrow before I painted it. I removed the masking on the plants last.

2 Painting Techniques

It is wonderful to see something and then create a way to express it with watercolor. We call those ways techniques. Mastering techniques frees you to be more creative, but techniques do not make a painting. They will not give you sight. Techniques are only means by which you express your vision.

Become a master of applying and inventing techniques.

More often than not, the discovery of a technique involves new ways of letting the water and the pigments do the work. The techniques and procedures on the next few pages are only examples of ways to handle the medium—you may develop your own solutions.

Painting With Brushes

Each brush performs a specific range of tasks. The following exercises will help you explore the potential of each type. Regardless of the type of brush, using a no. 8 or larger increases the range of marks you can make.

TIP FOR PRACTICING BRUSHSTROKES

If you practice your brush-strokes with clear water on any absorbent colored paper, such as brown wrapping paper, you will see your brush marks without having to waste paint and good watercolor paper.

CONSTRUCT SHAPES WITH YOUR BRUSHSTROKES
Avoid outlining a shape with your brush and then filling in the hole with paint like a coloring book. Instead, build up your strokes for the shape until you achieve the size you want.

FOLLOW THE CONTOUR
When painting around the edge of a shape (negative painting), turn the brush so your stroke follows the shape's edge. This is particularly important if you are using a flat brush.

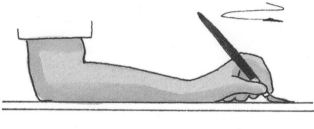

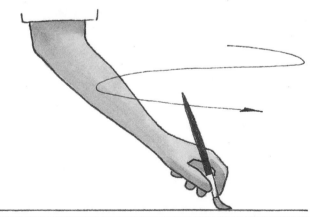

YOUR ARM IS NOT A WINDSHIELD WIPER
Vary the direction of your brushstrokes.

STAND UP
When you sit down, you have a tendency to paint from the wrist or elbow. That can lead to the windshield-wiper syndrome, which causes you not to vary your brushstrokes. Standing up allows for far greater movement of the whole body. That translates into greater variety and expression in your strokes. Save the sitting down for when you want more control for small areas and detail.

ROUND BRUSH TECHNIQUES

Whether synthetic or natural, a round brush is the basic watercolor brush that most watercolor artists feel comfortable using. However, remember that even this brush can produce a wide range of marks depending on how it's held and the direction in which you move it.

GAINING CONTROL OF THE ROUND BRUSH

It's hard to gain control of line width when your hand is off the paper. This is why people sit down to paint—so they can steady their hand on their elbow or wrist. The way around this is to use your little finger as a depth control while holding the brush vertically. This allows you to control the stroke weight while you remain standing. This technique also makes it possible for you to twist your brush to produce a fine point at the end of a stroke.

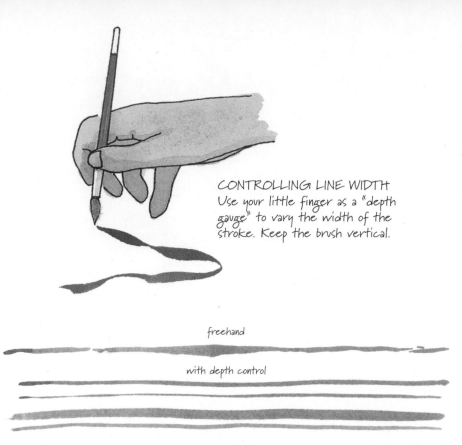

CONTROLLING LINE WIDTH
Use your little finger as a "depth gauge" to vary the width of the stroke. Keep the brush vertical.

freehand

with depth control

EXERCISE 1: GET CONTROL OF YOUR BRUSH
Stand up and try making a long, fine, continuous line of uniform width while touching the paper with the brush only (not with your fingers, hand or arm). Now, support your hand on your little finger, lower the tip of the brush to the paper and repeat the line. Now you should sense control. Practice making these lines of consistent width until this hand position feels natural.

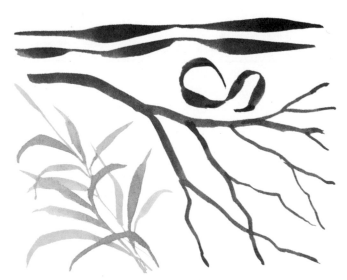

EXERCISE 2: PRACTICE VARYING LINE WIDTHS
Practice making lines that go from wide to thin, then thin to wide, using your little finger as a guide. Practice this on tree branches that change direction and weight. Try large blades of grass, curving lines and zigzags.

EXERCISE 3: PRACTICE PAINTING CLOSE LINES
Paint a line of varying width across your paper. Now paint a second, roughly parallel, line that is close to but not touching the first. To paint this line, you will need to vary the weight precisely with your little finger. Keep adding lines until you feel you are gaining control over the width of the lines you make.

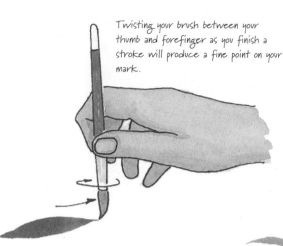

Twisting your brush between your thumb and forefinger as you finish a stroke will produce a fine point on your mark.

EXERCISE 4: TRY TWISTING YOUR BRUSH
Try twisting your brush on some flowers with long petals, some rushes or leaves.

SCRIPT AND RIGGER BRUSHES

Script brushes have fuller bodies and more pointed tips than riggers. Therefore, they carry more paint and produce a wider range of marks when you apply pressure to them. Both scripts and riggers make marks that are fairly consistent in width, but the length of their bristles can make them hard to control. Script brushes are best for free-flowing lines and shapes that suggest spontaneity. The large rigger is handy when you want a mark that is consistent in width and squared at the ends, like bricks, boards, stems, windows, etc.

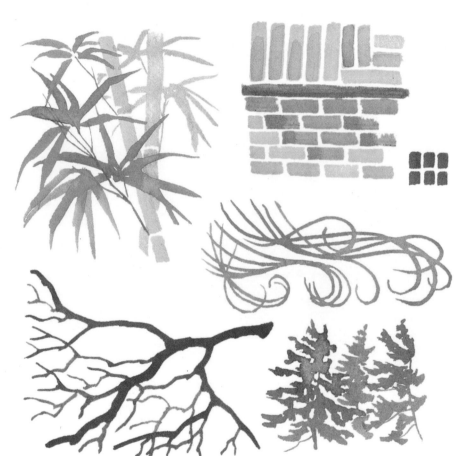

EXERCISE 5: SCRIPT AND RIGGER BRUSHES
Suggest growth or movement—for example, grasses, tree branches, hair, wood grain, etc. Experiment with stopping, starting and changing direction with your brushstrokes. Try building complex shapes by applying more pressure to the brush or drawing the brush sideways. Experiment with the rigger's ability to make squared lines.

script

rigger

FLAT BRUSH TECHNIQUES

Flat synthetic brushes include wash and stroke-type brushes. These flat brushes are some of the most versatile to own.

Flat hog hair brushes, though not generally given recognition as watercolor brushes, are stiff, coarse workhorses that can produce some truly unique marks. Having several widths from one to two inches will prove invaluable. For these exercises, it is best to use paint and real watercolor paper.

EXERCISE 6: KEEP STROKE WIDTH THE SAME
Now make circular marks of the same width by turning your synthetic flat brush and your arm as you make the marks.

EXERCISE 7: MAKE SINGLE "LEAF" STROKES
Start off narrow, pushing down on your synthetic flat, twisting 90° and then letting up on the pressure while turning 90° again. Try varying the length of these leaf marks. Try grouping and arranging to make more complex shapes.

EXERCISE 8: VARY WIDTH WITH BRUSH MOVEMENT
With a flat synthetic brush, make a variety of marks that vary in width depending on the direction you move. Keep the brush oriented in the same position—for example, horizontal—for each stroke. Move your whole arm with each stroke.

EXERCISE 9: TWIST BRUSH TO VARY WIDTH
With a synthetic flat, make marks that vary in size by twisting the brush 90° as you make a straight stroke.

EXERCISE 10: PRACTICE CLOSE STROKES
With a synthetic flat brush, make a single stroke across the top of your paper. Vary the width of this stroke by turning the brush as you go. Now paint a second parallel stroke that also varies in width but follows the curves of the first without touching it. In order to maintain a consistent distance between the strokes, carefully control the amount of turn on the brush. (Focus on the gap between the lines and not on the strokes themselves.) Continue to add strokes, with each fitting into the curves of the previous one.

EXERCISE 11: REPRESENT WAVE MOVEMENT

Repeat the previous exercise, making the marks shorter and adding in zigzagging. You are now making marks that you can use to represent wave movement.

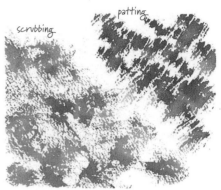

scrubbing patting

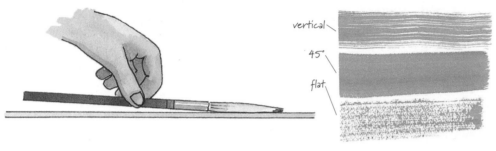

vertical

45°

flat

EXERCISE 14: PAT AND SCRUB FOR TEXTURE

With your hog hair flat, discover what marks you can make by gently patting the side of a well-loaded brush on your paper. Discover what textures you can make by scrubbing the side of a loaded brush on your paper. The more textured the paper, the better the effect.

EXERCISE 12: DRAG FOR REALISTIC EFFECTS

By holding and dragging a well-loaded hog hair flat at various angles, you can get everything from lines (held vertically) to a solid mark (held at 45°) to broken lines (held flat). To get the brush low enough you will have to change your grip, because you want just the side of the bristles to touch the paper. These marks are useful for wood grain, sparkle on water, grass, fabric, rust and old paint, but I am sure you will find lots of uses of your own.

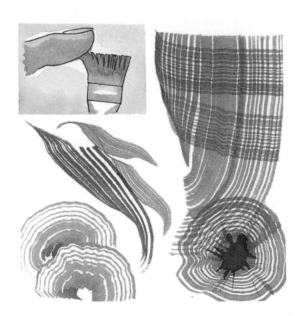

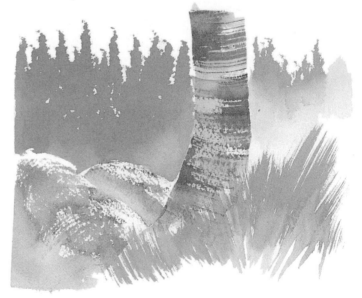

EXERCISE 13: DRYBRUSH FOR REALISTIC EFFECTS

Load a flat, short-bristled synthetic brush with concentrated paint. Wipe off excess moisture, then fan the bristles with your fingertip. The brush should be dry enough to allow the bristles to remain spread apart. Now you can make precise dry-brush marks with a flat synthetic brush. Great for wood grain, fabric, veining in leaves, hair, etc.

EXERCISE 15: PUT VARIOUS TECHNIQUES TOGETHER

Holding your hog hair flat vertically, make marks by dabbing the edge on your paper or by making short, sweeping marks. By varying the angle of the brush, repeating the mark over and over, you will soon discover textures and marks that can serve for grass, hills, bark, fur, rocks, clouds, etc.

Painting With a Palette Knife

Although palette knives have long been used for applying oil and acrylic paint, not everyone knows that you can also use knives for applying watercolors. Once you have cleaned your knife as described on page 28, the next step is to get the paint onto the knife blade.

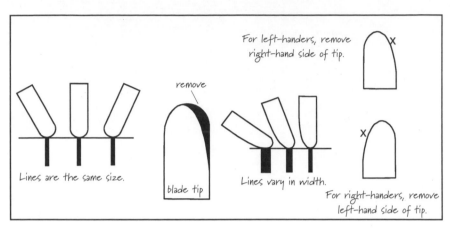

Lines are the same size.

blade tip

remove

Lines vary in width.

For left-handers, remove right-hand side of tip.

For right-handers, remove left-hand side of tip.

RESHAPE TIP TO VARY STROKES
A regular mixing knife blade will make the same width mark no matter what angle it's held at because of the consistent curve of the tip. By reshaping the tip so the curve changes as it rounds the end, you can produce marks that vary in width as you change the angle of the knife. To modify the tip, grind it down and then smooth the edges with extrafine sandpaper or emery cloth so there are no burrs.

LOADING THE KNIFE
Mix a pool of concentrated pigment in an open area of the palette (not too thick, as it has to flow off the blade). Place the knife's blade face down in this paint and slide it around. The paint should adhere to the entire face of the blade. You are now ready to paint with your knife.

MAKING MARKS
The easiest things to paint with a knife are lines, but these lines have a character unlike any lines made with a brush. Hold the knife at a steep angle, and drag the tip across the paper.

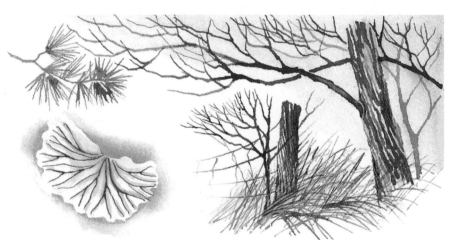

GIVE IT A TRY
Knives are great for making branches, twigs, grass, cracks in wood, fence wires, etc.—wherever you want a free-flowing fine line with a constant width. The size of the line obviously depends on the size of the tip on the knife.

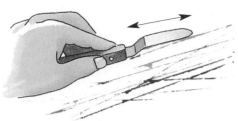

USING THE KNIFE'S EDGE TO APPLY PAINT
By pushing and pulling it you get fine lines.

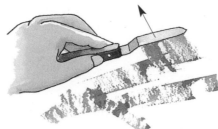

DRAGGING THE KNIFE SIDEWAYS
You produce marks that suggest tree bark or texture on rocks.

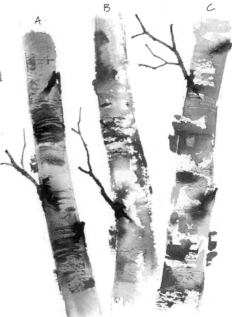

Painting With Sticks

Once you have cut your stick to the desired size and shape, all that remains is to add paint and start drawing.

THREE WAYS TO PAINT TREE TRUNKS WITH A PALETTE KNIFE
A. Paint applied to a tree shape that was completely wet beforehand.
B. Paint applied to a tree shape that was first made partially wet with a small hog hair brush.
C. Paint applied to a tree shape that was dry, then faded out in places with a wet brush.

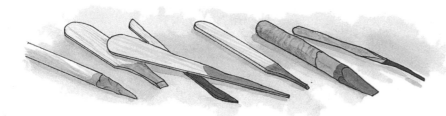

SHARPEN STICKS FOR PAINTING LINES
You can sharpen any type of small stick in a variety of ways for painting precise lines. Use a brush to load dowels, tongue depressors, Popsicle sticks or twigs with paint.

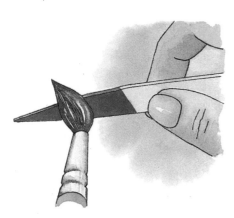

EXPERIMENT WITH YOUR PAINTING STICKS
You will find that sticks can produce very precise, consistent lines, useful for detail work.

LOADING THE STICK
Mix the desired color with a brush, then apply it to the end of your stick. It may take a moment for the stick to absorb the first charge of paint.

Painting With a Sponge

See page 29 for the preparation of your sponge. Wear a rubber glove, since many paints still contain pigments that are toxic. Besides preventing your own demise, you will also avoid the embarrassment of going into public with multicolored fingers.

GETTING PAINT ON THE SPONGE

You need a large puddle of paint in the mixing area of your palette, as well as a sponge fully saturated with paint. To do this, rub a wet sponge in your desired color, then squeeze out this mixture where you want it in your mixing area. Keep repeating this until you have a large puddle from which you can fully charge the sponge. I cannot overemphasize the need to fully saturate the sponge for this process. It doesn't matter how concentrated the pigment is, as long as the sponge becomes fully wet with paint.

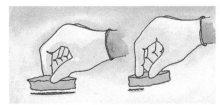

HOLDING THE SPONGE

Hold your sponge on its side so the sides with the holes face up toward you and down toward the paper. You will be painting with these faces and not the sides of the sponge. Most people find that working with the tip of the sponge gives them more control when building shapes. If you wish, use your forefinger to add support to the tip of the sponge. I recommend that you use a rubber glove.

See page 29 for the preparation

TOO MUCH ENTHUSIASM

Practice on scrap paper, and try to curb your enthusiasm. Don't slam the sponge onto the paper as if you were killing ants at a picnic! This procedure demands a sensitive touch, and you'll need a sharp eye to keep a watch on each mark formed.

too little paint

EXPERIMENT

Experiment to find out what kinds of marks your sponge will make. Load it with paint, then gently touch it to the paper so that it leaves an irregular mark. If you load the sponge properly, it will take very little pressure to leave an impression. Practice until you can make clearly defined marks that still leave white areas within the marks. Try tilting the sponge from side to side to alter the marks. Flip the sponge over. Try both ends.

Too little paint on the sponge will produce a soft, lacy shape that lacks definition. If you wish to paint a pale shape, then add water to the paint mixture as you would if you were painting with a brush. If you wish to add more paint, just squeeze the sponge.

BUILDING SHAPES WITH A SPONGE

When painting large masses with a sponge, avoid making sporadic, isolated marks all over your paper. Most of the shapes you make with a sponge are made by building up marks. Make hills, trees, foliage and ground cover by starting with one mark and then adding to it until you form your desired shape. For example, for deciduous trees, start in the middle and work out from the center. For coniferous trees, start at the top and work down to the bottom. Work along a line for hills and ground cover.

THE BIG PAYOFF

Once you gain some mastery with a sponge, you will find that you can paint hills, trees, forests and foliage at astounding speeds. You can finish a whole forest and still have it wet for additional techniques in the time it takes to paint one tree with a brush. This opens the door for all sorts of wet-in-wet procedures (see page 48). An example is the forest. After sponging, I faded out the bottom edge with clean water and a brush, lightly spattered the forest with a spray bottle and then dropped in salt.

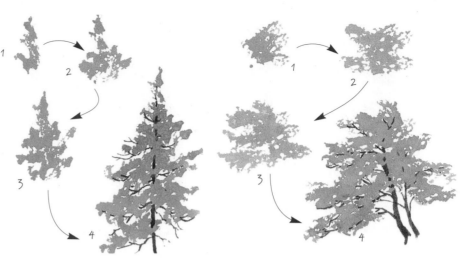

HAVE FAITH

Paint in trunks, branches and stems with a brush after painting the leaves. It takes a wee bit of faith that this meaningless mass of shapes will actually turn into something.

Start coniferous trees at the top and work down to the lower branches. Start deciduous trees in the middle and work out to the outer leaves.

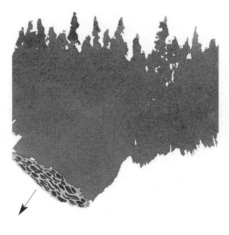

SPREAD PAINT
Spread paint by dragging the sponge.

USE SPONGES WITH OTHER TECHNIQUES
Because the whole shape is wet, you can use additional techniques, such as adding salt, which will bleach some of the color to produce a mottled pattern.

CREATING TEXTURE WITH SALT

Sprinkle grains of coarse salt into semi-wet paint. When the paint is dry, brush off the salt to reveal a pale, delicate texture where the salt granules have soaked up the pigment. You can use salt to create texture in ground, tree and background areas.

EXAMPLES OF SPONGE PAINTING

ON THE ROCKS
15" x 22" (38cm x 56cm)
Private collection

A RANGE OF SPONGED COLORS
I sponged in the blue-gray trees in the background of this picture first. When that was dry, I added the orange foreground trees. This is a good example of how you can sponge a range of colors on a shape. I did this by preparing a selection of oranges on the palette beforehand, then picking up different variations on the sponge, without washing it out, as I went along. I used Cadmium Orange, Cadmium Red Light and Cobalt Blue to produce my selection. Most importantly, I painted the tree trunks in after the leaves were in place.

This painting is also a good example of sun spots created by lifting color with water and a small "scrubber" brush.

HEADWATERS
11" x 19" (28cm x 48cm)
Private collection

ILLUSION OF LIGHT WITH SPONGING
In Headwaters, I achieved the appearance of light coming through the forest by sponging lighter, warmer greens at the light source and gradually applying cooler, darker greens as I moved away from it. After the foliage was dry, I painted in the tree trunks. By making them darker than the leaves, I created the appearance of atmospheric clarity.

THE NARROWS
Detail
22" x 30" (56cm x 76cm)
Private collection

ATMOSPHERICS
I created the appearance of fog in this detail by fading out (see page 46) the base of the sponged trees. I could do this because the trees were a consistent wetness. This process of painting trees and then fading them out was repeated several times to create a sense of depth.

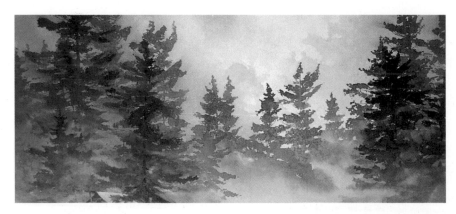

How Paints Interact With Water

The term *watercolor* would seem to suggest that the end result of a painting should look as if water had something to do with its creation. If your work looks like a paint-by-number because you have worked entirely in a wet-on-dry fashion, then you have missed the whole point of the medium. How will viewers know that it's a watercolor? There are endless ways of working so that water has an active role in the process and the effects you get.

THE LAW YOU CANNOT IGNORE

Basically, greater wetness will always flow into lesser wetness. The wetness could be either water or paint, and it does not matter where it is. The greater will always flow into the lesser in an attempt to balance the system out. You can see the effects that wetness has on the painting process.

GREATER WETNESS FLOWS INTO LESSER WETNESS

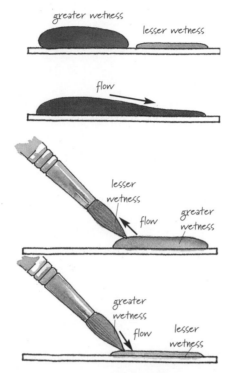

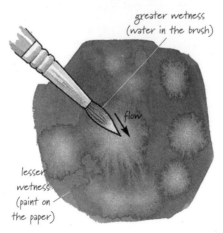

If the greater wetness is water and the lesser is paint, then the water will flow into the paint, pushing the pigment aside. We call this a water spot, water blossom or run-back. Knowing how to create or avoid a blossom is of great importance in the painting process.

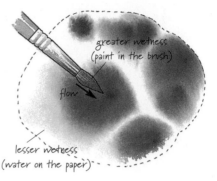

If the greater wetness is paint and the lesser is water, then the paint pigments disperse smoothly into the water.

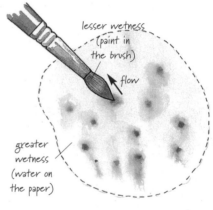

Little happens here when the brush is less wet than the surface because the brush is trying to pick up water.

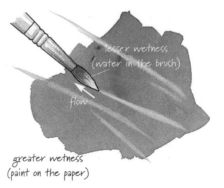

Now you can lift off color as the paint attempts to climb into the brush.

Mastering Washes and Glazes

Washes are large, thin layers of color that cover the whole or partial areas of your paper. A wash that is usually applied to white paper can be uniform (flat) or graded in color or value. A glaze is a wash applied to an already-dry painted surface. Washes and glazes play an important mood-setting and unifying role in your painting.

GLAZING

This is the process of laying on a colored wash over paint that is already dry. You can use it to "adjust" a painting that may lack mood, unity or focus. While a single color helps to establish a more dominant mood within a work, it also adds to unity by giving all the colors a common overcoat. Darkening a selected part of a painting with a glaze helps the eye focus on more important lighter areas.

Glazing can be a tricky process because you are placing a very wet layer of paint over paint that is already in place. It is important to apply the paint quickly with a large brush and to avoid overworking any part of the surface, so as not to disturb the paint that is already there. When you glaze only part of the work, it is important that there not be any hard edges left from the glaze. Use water to fade out any edges.

One way to glaze is to wet the surface of the picture first with a spray bottle, then, while this is wet, drop or pour liquid watercolor into it. Tilt the painting to help direct the flow, and use additional spray to fade the edges. Even though there is no direct contact with the paper, there is still the danger that some colors, particularly dark opaque colors applied heavily, will blur. You will see this happening when the paper is first wet with the spray. Use the spray to wash away the blurring paint before you apply the glaze color. When the painting is dry, reapply the darks, if necessary.

LAYING ON A GRADED WASH

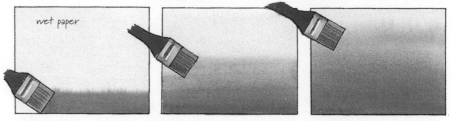

METHOD 1

Wet the desired area completely. Immediately paint concentrated pigment along one edge. Fade out that paint into the wet area with long strokes. To intensify the color, repeat this process, each time starting at the beginning. With each application the color deepens and extends into the wetted area.

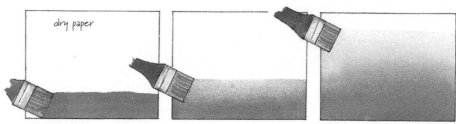

METHOD 2

With the paper dry, paint concentrated pigment along one edge of the wash area. Dip your brush (which still has paint in it) into clean water, and wipe off excess water on the side of the container. Apply this now-diluted color next to the first stroke. Keep repeating this fading-out process until you have achieved the look you want and there is no pigment left on the brush.

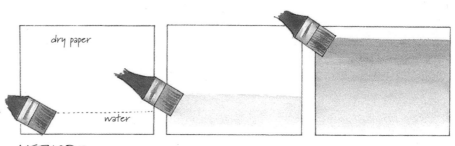

METHOD 3

Prepare your desired pigment in a concentrated puddle. With the paper dry, start by painting the edge of the wash area with a stroke of water. Charge your brush with water and a touch of the desired pigment. Apply this in long strokes along the edge of the wet area. Pick up more pigment only and apply it along the new edge. Repeat this process of adding more pigment (not water) with each stroke until you reach the other side of the wash area.

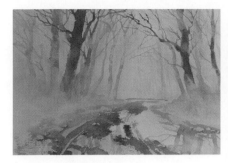

before

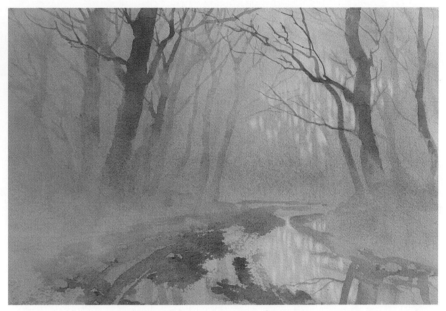

after

MOOD ADDED WITH A GLAZE

I painted a thin wash of Cobalt Blue through the center of this foggy road picture when it was dry. It provided the perfect opportunity to remove "sun spots" in the tree and puddles with a smaller scrubber brush.

before

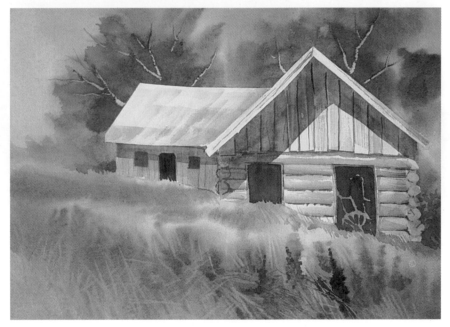

after

GLAZING HELPS FOCUS VIEWERS' EYES

Darkening some part of the picture, in this case the corners, with a thin glaze of Ultramarine Blue causes the eye to go to the remaining light area.

SECRETS TO ACHIEVING SUCCESSFUL WASHES

Stand so you can use your whole arm, work with large flat brushes, prepare lots of pigment in a large mixing area beforehand and tilt your board slightly to help the paint flow.

Fading Out a Color

Also called *pulling out* color, *pulling off* color or *softening an edge*, this technique is useful for achieving various effects in watercolor because of how the human eye perceives the edges of shapes. If an edge is sharp or well defined, we say that it is a *hard* edge—it attracts the eye, which will follow along its length. If an edge is fuzzy or indistinct, we say that it is a *soft* edge. The process of fading out gets viewers to see the hard edges you want them to see by softening the edges you do not want them to notice.

The terms pulling out or pulling off colors are misnomers because they indicate that you are physically moving the paint. To produce the effects you want, you must allow the water to move the paint in its own way. Your job is to place just the right amount of wetness in just the right spot at just the right time so the medium can do what it does best.

First, the direction in which you apply the water that will pull out the color is important. Do not reach into the paint and move it out with your brush. You will indeed spread the paint around, but you will not produce the smooth, graded effects that you want. What you are trying to do is to make a path of water movement that will attract the paint. This, of course, works best if the paint area is very wet and the brush is less wet or just damp.

BRUSHES FOR FADING OUT

For fading out small areas in a painting, either natural or synthetic brushes will work fine. However, synthetics have two drawbacks: They are unable to hold a large charge of paint for fading out large areas compared to natural bristles, and they have a habit of releasing their load all at once. Both of these features can make them frustrating when you wish to pull off a large body of color smoothly. Natural fiber brushes (squirrel, sable, goat, badger, ox, hog), on the other hand, hold a greater charge and release it more consistently, which makes them far better suited to this job.

To fade out color, you must apply water to the edge of the paint with a brush that is drier than the paint. A natural fiber brush, such as the hog bristle, will lay down a long path of water that is consistent from one end to the other. Synthetics tend to dump too much moisture at first, leaving about the right amount halfway and running out before getting to the end of a large area (see pages 18–19). The result is a runback at the beginning, proper fading in the center and nothing at the end.

However, if the paper is wet first and you wish to add paint for fading out, you want a brush that releases its load quickly. In that case, a synthetic is the best choice for the job.

SOFTENING EDGES
Until one side of each mark above is softened, you are not quite sure what the subject is.

natural bristle
brush stroke

synthetic bristle
brush stroke

AN ALTERNATIVE METHOD OF FADING OUT COLOR

The reverse process for fading out color is to wet the paper first and then add color to it. Use this technique for large passages, such as skies, and for small areas, such as negative shapes. Negative shapes are the areas in an artwork not occupied by subject matter but utilized by the artist as part of the design (see pages 72–77). The only thing to remember is that the brush must be wetter than the surface moisture if you wish to achieve maximum flow for fading, because of "The Law You Cannot Ignore" (page 43).

FOLLOW THE EDGE
In all cases, the brush is just damp and the paint is very wet. Make your stroke with the water, following the edge of the painted area. Be careful to just touch the color.

DON'T GO TOO FAR IN
If you go into the paint too far, your damp brush will act like a sponge and soak up the paint instead of causing it to spread.

MAKE SUBSEQUENT STROKES OUT FARTHER
It may take several strokes to get the paint to move, but when it does, make the subsequent strokes at a greater and greater distance out. The paint will follow.

Working Wet-in-Wet

Working wet-in-wet means painting on a wet surface—any wet surface, whether it's wet with clear water or a mixture of paint and water. It is important to understand the role that the wet-in-wet process plays in the unique appearance of watercolors.

Nothing utilizes the potential of watercolors like the process of working wet-in-wet. To help you find techniques of your own, I have organized the painting process into three steps, each with options for you to explore. Basically, you start by wetting the paper in some way, then add color in some way to this wetted area, then extend the process. The unique results you get depend on the options you choose in each of these three steps.

COVERAGE

all over

in an irregular pattern

defines specific shapes

partially cover the surface

OPTIONS FOR WETTING THE PAPER

METHOD

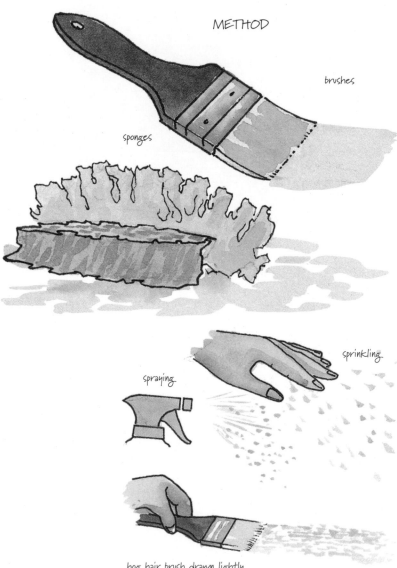

brushes

sponges

spraying

sprinkling

hog-hair brush drawn lightly
across the surface

OPTIONS FOR ADDING PAINT

Now you have choices in the way you apply paint to the wet paper, but remember that at any time you could tilt your paper to help colors move. Also realize that a damp surface will not react to paint in the same way a wet one will, so experiment with the degree of wetness on your paper. There are many different combinations of wetting the paper and adding color for you to explore.

WET BY SPRAYING, PAINT BY POURING

If you wet the paper by spraying and add paint by pouring, you get something like this.

WET PARTIALLY, PAINT WITH A FLAT

You get this effect if you partially wet the paper with a hog hair brush and add paint with a loaded flat synthetic brush. You can get a similar effect by partially wetting the paper and adding paint with a sponge.

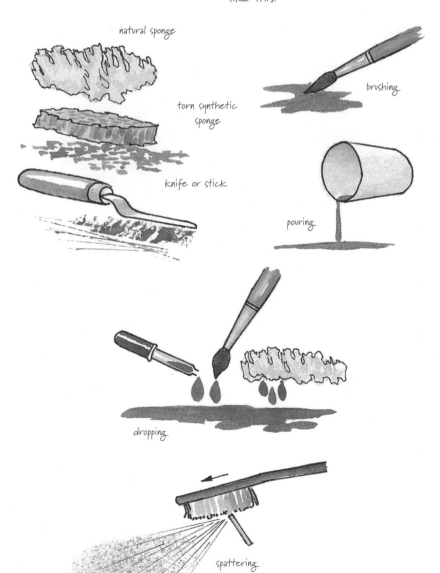

natural sponge

torn synthetic sponge

knife or stick

brushing

pouring

dropping

spattering

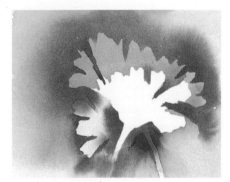

WET IN SHAPES, PAINT WHEN DAMP

If you wet the paper in specific shapes and add paint with a loaded brush when the paper is just damp, you get this.

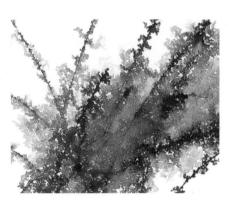

WET BY SPRAYING, PAINT WITH A PALETTE KNIFE

If you wet the paper by spraying and add paint with the edge of a palette knife, you get this effect.

SUSTAINING THE WET-IN-WET PROCESS

Once the paint in the wet-in-wet process begins to dry, that is, to lose its shine, you enter a "magic time" in watercolors—a time when the medium comes to life. It is in these few moments, when the paint takes on a dull sheen, that you can perform many unusual techniques. You will not have much success if you try too soon or wait too long. It's at this damp stage that adding more color or water or removing paint can give the most dramatic results.

Every time you add paint or water, you add moisture to the paper—in effect, you sustain the "magic time." It is best that you use only nonstaining, transparent to semitransparent colors for this wet-in-wet process, because they are delicate, have good flow, and have the capability of leaving lighter areas when blossoms occur.

Options A and B are ways to add more water. Option C suggests ways to lift or move color. For adding color, use the methods suggested previously.

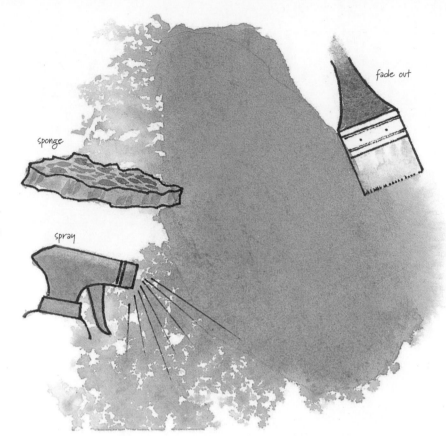

OPTION A
Add more water when the paint is wet.

DROPPING SALT INTO WET PAINT

This is also a way to remove paint, since the salt bleaches the color away, leaving irregular stars. The drier the paint, the smaller the stars are.

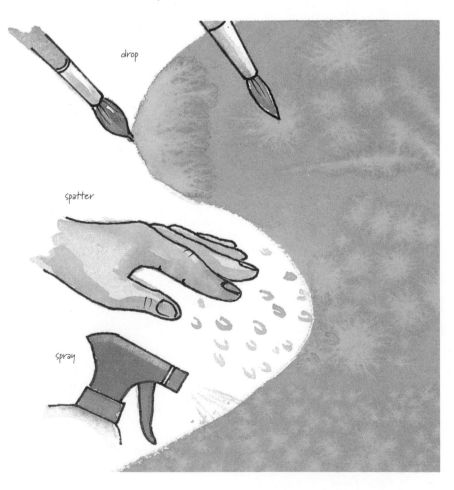

OPTION B
Add more water when the paint is damp.

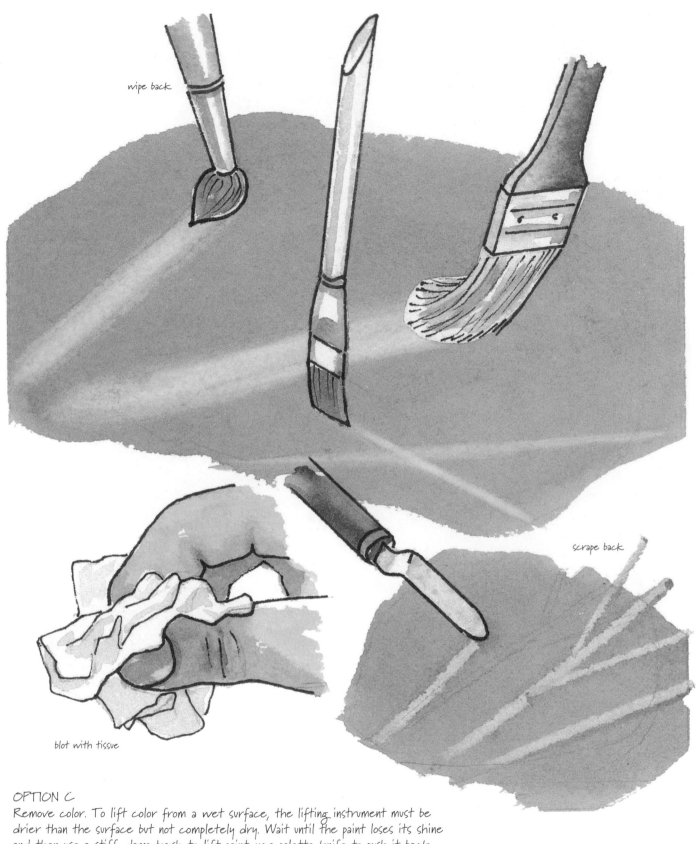

wipe back

scrape back

blot with tissue

OPTION C
Remove color. To lift color from a wet surface, the lifting instrument must be drier than the surface but not completely dry. Wait until the paint loses its shine and then use a stiff, damp brush to lift paint or a palette knife to push it back. You can also remove paint by wetting an area as in option A, wait a few moments, and then blot with a clean dry tissue.

LAKE SPIRIT
19" x 22" (48cm x 56cm)
Private collection

MOOD AND TEMPERATURE
Wet-in-wet painting is a means of covering areas of your painting with soft, nebulous passages of color that help set the mood and temperature of the work. In Lake Spirit, the soft, cool atmospherics also encourage our eyes to move to the hard edges of the island trees and the light patches on the water.

ELEMENT OF MYSTERY AND INTRIGUE
The ethereal effects created by the wet-in-wet approach can add that all-important element of mystery and intrigue to your work. With it you provide only the suggestion of reality—an area for the viewer's imagination to complete its own images. Here I intentionally left wet-in-wet areas for the viewer to ponder.

AUTUMN WALK
Detail
15" x 22" (38cm x 56cm)
Private collection

WET-IN-WET BACKGROUND AND FOREGROUND SHAPES
Sometimes wet-in-wet background shapes can evolve, with negative painting, into major foreground shapes and even the center of interest. Summer Choristers started as a loose wash of Cobalt Blue, Permanent Rose and Raw Sienna. After the wash dried, I used these same colors to carve out and model flowers from this background by painting around them.

SUMMER CHORISTERS
Detail
11" x 15" (28cm x 38cm)
Private collection

Masking

Masking is a technique used to cover an area temporarily in order to prevent it from being painted. It allows you to preserve delicate white areas or to develop special background effects that would otherwise be impossible. Masking should not be used as a crutch. Before using any masking material, ask yourself if you could just as easily save the area by painting around it (negative painting—see pages 72–77). If you do decide to use masking, test it on your paper first.

USING LIQUID LATEX

It is important that you use a decent brush to apply your liquid latex (also called masking fluid). If you use an old brush that you would not even paint with, as other books will state, you will end up with inferior brush marks and, therefore, less than desired shapes in the end. However, do not use a natural-fiber brush for applying liquid latex. The latex can damage the resilience of the fibers. Instead use a synthetic brush and protect it from the gum by first applying soap to it. When finished, immediately rinse, soap again, rinse, soap again and rinse. Your brush will last indefinitely. If you dedicate a couple of inexpensive synthetic brushes for masking, you won't have to risk your more expensive ones.

TIP FOR REMOVING LIQUID LATEX

If all else fails, lighter fluid will remove masking fluid that has dried on your brush.

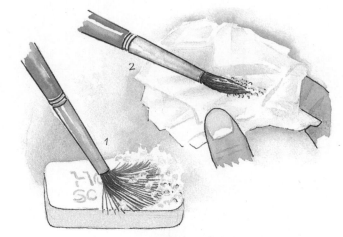

PROTECTING YOUR BRUSH
Before dipping your brush into liquid masking material, make sure you have soaped the brush well. Wipe excess soap from the brush with a tissue before use. Use a synthetic brush.

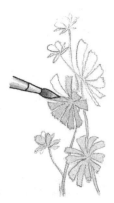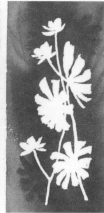

BASIC PROCEDURE
Apply masking fluid and let it dry. Always double-check for small spots that you may have missed. When the masking has dried thoroughly, apply background colors and techniques. When the paint is dry, remove the masking fluid with a rubber cement pickup.

OTHER WAYS TO APPLY LIQUID LATEX

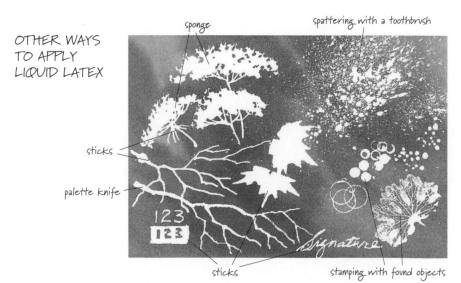

sponge

spattering with a toothbrush

sticks

palette knife

sticks

stamping with found objects

ROYAL VISIT
19" x 22"
(48cm x 56cm)
Collection of the
artist
Photographer:
Kevin Dobie,
Kevanna Studios

USING BOTH ENDS OF YOUR BRUSH

In Royal Visit, I applied the masking fluid for the Queen Anne's lace with a sponge and the butt end of a paintbrush (for individual florets). For the stems, I applied it with a sharp stick, and for the butterflies, grass and chicory flowers I used a brush. Once the background was dry, I removed the masking. Before I painted the butterflies, I saved the white spots on their wings by reapplying masking fluid, again with the butt end of a paintbrush.

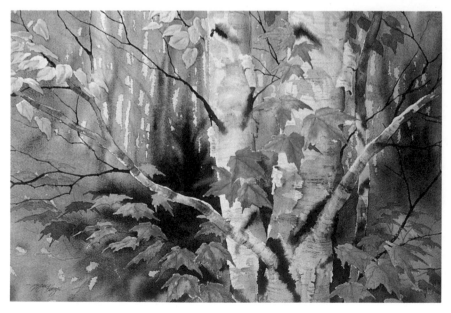

AUTUMN BIRCH
15" x 22" (38cm x 56cm)
Private collection

SOMETIMES YOU HAVE TO MASK OUT TWICE

Here, masking fluid for the trunks of the birches and their leaves was painted on with a brush. For the branches, I used a palette knife. I masked out the maple leaves using a flat, chisel-ended stick. I painted the background and let it dry. I removed the masking fluid, but before I could paint the birch trunk, I had to mask the leaves in front of it, again with a flat, chisel-ended stick.

STEP BY STEP: MULTIPLE MASKING

This is a technique of repeated masking over previously painted areas in order to preserve colors and shapes. It has a very unusual visual effect. Multiple masking requires a paper with great endurance, such as 140-lb. (300gm) or 300-lb. (640gm) watercolor paper. This process takes a while to complete because of the drying time needed between steps. Don't try to rush things by drying masking fluid with a hair dryer or in the sun. You will adhere the masking fluid to the paper.

Transparent to semitransparent colors are best for multiple masking because they are delicate and their transparency makes them excellent for layering. I use Cobalt Blue, Burnt Sienna, Red Rose Deep and Indian Yellow in the following demonstration. I did the masking with a brush and a palette knife.

WHAT YOU NEED

140-lb. (300gm) or 300-lb. (640gm) watercolor paper
masking fluid
masking brush
transparent to semitransparent watercolors of your choice
palette knife
watercolor brushes of your choice
salt

1. MASK OUT MAJOR FOREGROUND SHAPES.
With masking fluid (liquid latex), mask out major foreground shapes that you wish to remain white. Let the masking fluid dry.

2. PAINT OVER THE MASKED AREA.
Apply a thin wash over the masked area — a mixture of Cobalt Blue, Burnt Sienna and Red Rose Deep. Let the wash dry.

3. MASK OUT MORE SHAPES.
Shapes can overlap previous ones. Let the shapes dry.

4. PAINT OVER THE MASKED SHAPES.
Apply a mixture of Cobalt Blue and Burnt Sienna over the masked area. Add salt in ground and tree areas. Let the paint dry.

5. MASK OUT EVEN MORE SHAPES.
Again, shapes can overlap previous ones. Let the shapes dry.

6. PAINT OVER THOSE MASKED SHAPES.
Apply a mixture of Cobalt Blue and Burnt Sienna over the masked area. Add more salt in the background. Let the paint dry.

7. MASK OUT STILL MORE SHAPES.
Shapes can overlap previous ones. Let the shapes dry.

8. PAINT OVER MASKED SHAPES AGAIN.
Apply mixtures of Cobalt Blue, Burnt Sienna and Red Rose Deep over the masked area. Let the paint dry.

9. REMOVE ALL THE MASKING FLUID.
Remove all the masking fluid with a rubber cement pickup.

IT'S LIKE OPENING A PRESENT

When the painting is so dark that you can't see what you are doing, you should probably stop. Wait until the painting is perfectly dry, then remove all the masking gum with a rubber cement pickup (used to pick up excess dried rubber cement from paper or other surfaces). This is like opening a present. Bit by bit it reveals colored shapes overlapping into the darkness. The gum has a tendency to remove some color from the page, so you may want to go back in with more concentrated colors. You also may want to suggest shading and cast shadows on major shapes.

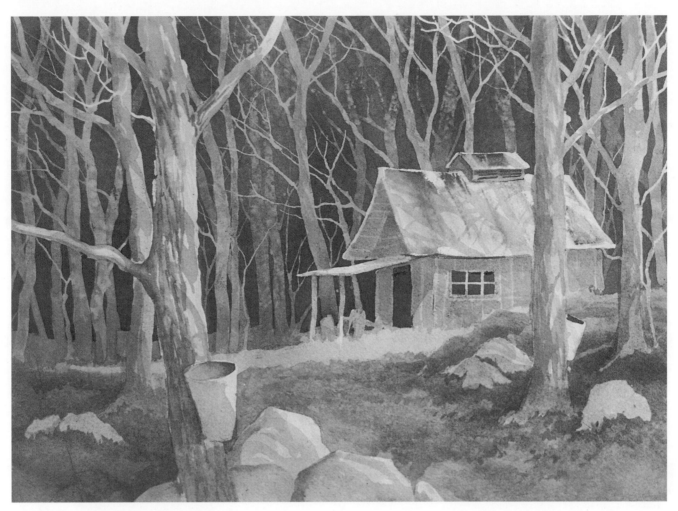

10. PAINT FOREGROUND SHAPES.
Touch up colors, then add shadows.

MASKING TAPE

You can put down masking tape in overlapping pieces to cover a large area, then cut it with a sharp craft knife to the desired shape. You can tear it lengthwise and then put it down to produce an irregular edge around an object. You can use it with a piece of paper in order to save tape. You can cut it into strips and then apply it to the painting.

DISADVANTAGE OF MASKING TAPE

Because of the thickness of some masking tape and the roughness of watercolor paper, paint sometimes seeps in underneath the tape, even when you think you have pressed it down firmly.

PACKING TAPE

This is the thin, 2-inch-wide plastic tape used to wrap parcels and boxes. It comes in clear, but buy the brown or gray so you can see it on the paper. It is transparent enough for you to see a preliminary sketch right through it. Do not buy the "heavy weight" grade. The cheap economy grade is thinner and does a better job of following the texture of the paper.

You can quickly cover large areas with this tape. You can cut shapes from it more easily than from masking tape, using a very sharp (fresh blade) craft knife and applying just the *slightest* pressure to cut the *tape* and not the paper. You will learn through practice how much pressure to put on the craft knife. Try it on a test paper or old painting first.

Lay the tape down with just enough pressure all over to hold it in place. Cut the desired shapes, then carefully lift the corner of the tape and remove the tape from the areas you do not need to mask. With only the desired shapes on the paper, press the tape down firmly. A clean rubber brayer (a hand roller) is excellent for this job.

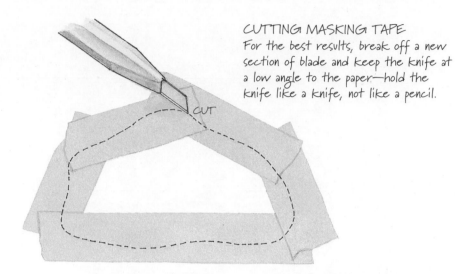

CUTTING MASKING TAPE
For the best results, break off a new section of blade and keep the knife at a low angle to the paper—hold the knife like a knife, not like a pencil.

CUT

CUTTING TAPE OUTSIDE THE PICTURE
By placing a piece of tape on a smooth, hard surface, you can cut it into fine strips using a knife and ruler. Use these fine strips to define architectural detail. Press down well before painting.

REARRANGING TORN TAPE
Tear the tape lengthwise. Rearrange the pieces to produce a shape with rough edges. Good for tree trunks and rocks.

TIP FOR LIFTING TAPE

You can lessen the tape's grip on the paper by gently warming it with a hair dryer.

ADVANTAGE OF PACKING TAPE

As mentioned above, because packing tape is so thin, it tends to follow the contours of the paper surface better than masking tape. When the tape is firmly pressed down, there is no leakage, even on small pieces.

Unlike masking fluids, which you can remove only when the painting is completely dry, you can remove tape (very carefully) while the painting is still wet. You might want to do this so you can fade out a few edges of the masked shape(s) with a damp brush to blend them into the background. This helps eliminate a cut-and-paste look while adding flow and unity to the work.

DISADVANTAGE OF PACKING TAPE

Tape may split when you lift it, making it troublesome to get off the paper.

WHAT YOU NEED

watercolor paper
pencil
masking or packing tape
very sharp craft knife
watercolors of your choice

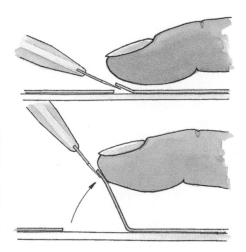

HOW TO REMOVE
PACKING TAPE
Use the tip of a knife blade to carefully lift a corner. Press the tape against the side of the knife tip with your index finger and together lift the tape gently.

STEP BY STEP: MASKING WITH TAPE

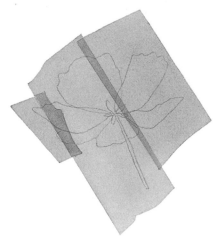

1. Cover your sketch with pieces of overlapping tape. Press down lightly.

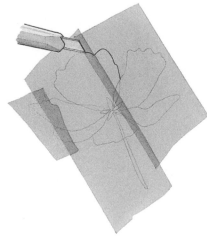

2. Cut around the shape with a very sharp craft knife, using just enough pressure to cut the tape.

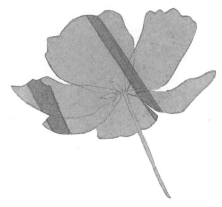

3. Remove unwanted tape, and rub down remaining tape firmly.

4. Paint on the desired background color.

5. When paint is dry, remove tape.

A Mix of Techniques

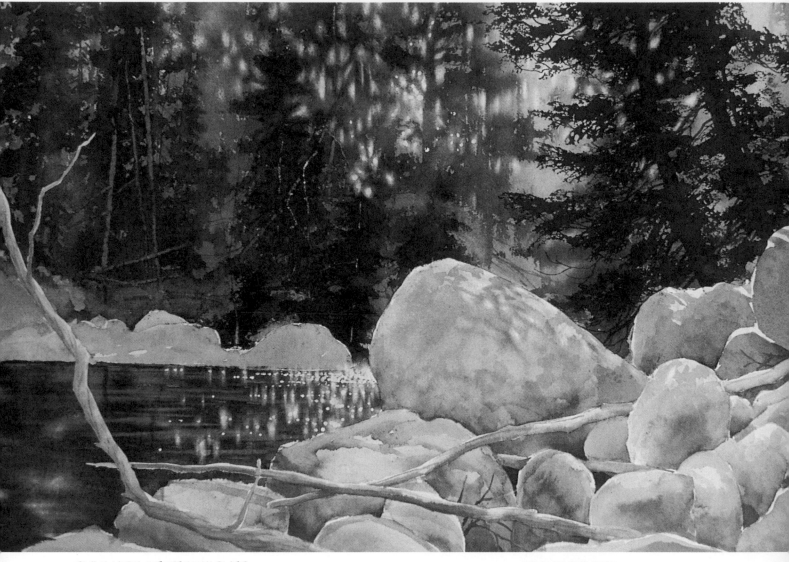

SUMMARY OF TECHNIQUES
Mottled rocks: drops of water dropped into damp paint. Background trees: partial wetting area with vertical strokes using a hog hair brush. I then painted the trees with a sponge. Foreground trees: sponged on when paper was dry. Water sparkles: masking fluid applied with the butt end of a brush for each sun spot. Smaller scrubber brush used to soften sun spots in trees, on water (when masking removed) and on rocks.

TROUT STREAM
15" x 22" (38cm x 56cm)
Private collection

DREAM LIGHTS
11" x 15" (28cm x 38cm)
Private collection

SUMMARY OF TECHNIQUES
This is an example of a sustained wet-in-wet process. I laid down an initial wash of Cobalt Blue, Permanent Rose and Raw Sienna. I continued to move between adding more water by dropping and spraying, adding more paint by brushing and dropping, and removing paint with a damp brush or tissue. When it had evolved into what I found pleasing, I stopped.

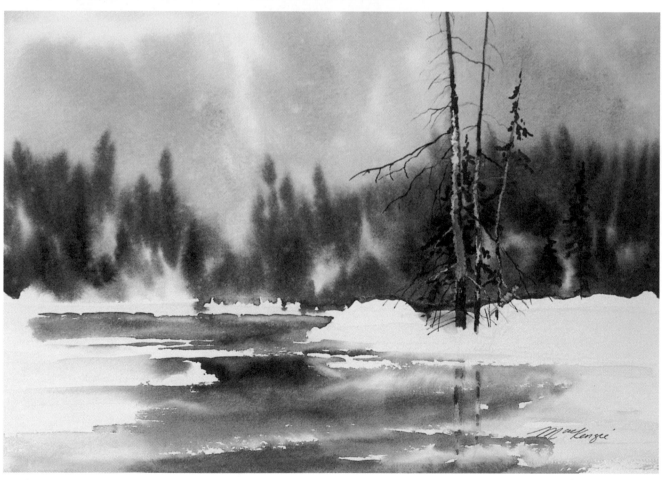

SUMMARY OF TECHNIQUES
Sky: a loose wet-in-wet wash of grays and blue carried halfway down the page. Shoreline: concentrated color added with hog hair brush while sky area was damp. Water: area partially wetted horizontally with large hog hair brush. I dropped in pigment with a large flat synthetic brush, then faded out around the edges with a damp hog hair brush. Tree: painted with a palette knife.

NOVEMBER BLUES
15" x 22" (38cm x 56cm)
Private collection

3 Putting Together Your Composition

You rarely find the perfect composition or design for a painting in real life. What you find instead are the seeds for a composition—the parts and pieces of ideas that you can combine or expand into a pleasing arrangement. You must manipulate and refine visual stimuli until they take on a whole new life of their own. The real magic behind the arts is the creation of new ways to express the ordinary.

You can learn much about composing pictures by studying works of more experienced painters, reading art books or taking workshops. In the process, you will encounter a conglomeration of rules, procedures and techniques, some of which will prove of value in composing your own pictures. However, the real source to rely on is within you. You already know how to compose. You did it once as a child, and now all you have to do is reawaken that instinctive ability by having the courage to believe in it and use it as you make compositional decisions.

Factors to Consider

Things to think about in your composition include subject, point of view and center of interest; picture format; closure; shapes, lines and edges; movement, repetition, pattern and rhythm; value, color, contrast and gradation. These are the elements and principles of your composition, or design.

Composing is the process of planning out your arrangement of shapes, lines, values, colors, etc., so you make the best visual statement possible. This process combines art, logic, skill, intuition and imagination. Alas, techniques alone do not compensate for a poor arrangement. On the other hand, a well-planned picture will survive some fairly sloppy techniques. Think of yourself as a "visual author." You have the right to manipulate the components of your picture in whatever way necessary to tell the most exciting story possible. Composing is just the process of thinking out the options and arrangements for your story.

SOME FUNDAMENTAL TRUTHS

1. It's our basic nature to create.
2. We all embrace an individual sense of what "feels right" that also seems to reflect an unconscious universal consensus.
3. We all go about creating what "feels right" differently.

SUBJECT

This is what your picture is about, e.g., the sea, flowers, buildings, people, etc. It's like the theme for a story and should emphasize those things that you find most appealing about the subject, i.e., color combinations, contrasts, shapes, lighting, mood, message, etc.

CENTER OF INTEREST

A picture needs a leading character. This most important object, area or aspect of your picture is called the focal point or center of interest. If you use strong contrast, unique color combinations and a pathway for the eye, the viewer will find it no matter where you put it.

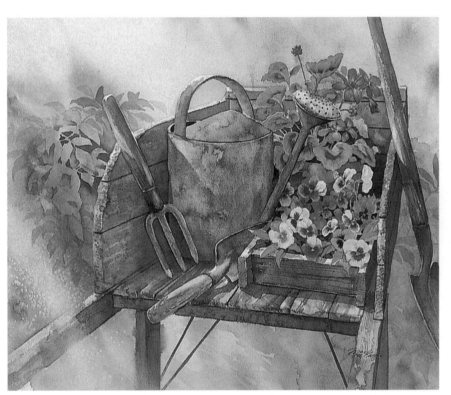

LOCATION LEADS THE EYE FIRST
A center of interest does not have to be the biggest thing in your picture, but it does need to have the greatest attracting power. It's an object's location, first and foremost, that leads the eye toward it—as well as value contrast, lines (edges), series of lesser shapes or unusual color.

In Planting Time, the convergence of the edges and handles of the wheelbarrow and the position of the garden fork and trowel lead your eye to the box of flowers. It is kept in this pocket by the leaning shovel and the spout of the watering can. The purity, uniqueness and light value of the flower colors contrast with the darker, dulled colors of other shapes in the composition.

PLANTING TIME
19" x 22"
(48cm x 56cm)
Collection of the artist

SEVERAL MINOR CENTERS OF INTEREST
It is possible to have several minor centers of interest to help lead the viewer around the picture. Take a look at Summer's Arsenal. The major object is the red-and-white lure. However, the other lures act as minor centers of interest, adding variety of shape, color and pattern that leads the eye back and forth along the wall.

SUMMER'S ARSENAL
15" x 22" (38cm x 56cm)
Collection of the artist

GOOD LOCATIONS FOR FOCAL POINTS
Divide your picture space into thirds vertically and horizontally. The intersections of these lines are good locations for a center of interest.

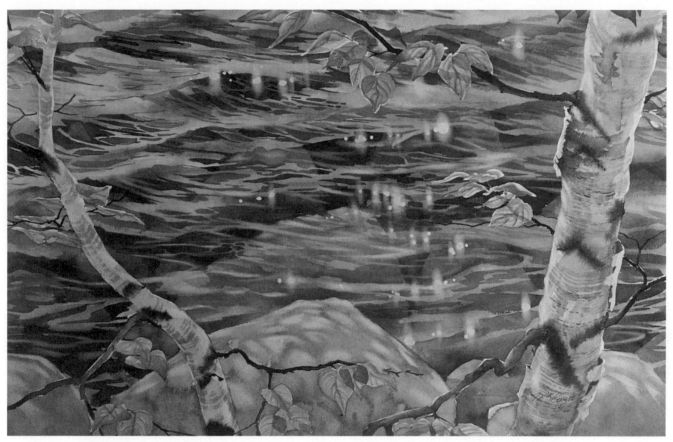

DRAW ATTENTION TO AN AREA

Sometimes, particularly in landscape painting, it is not a single object but an area to which you want to draw attention, such as sparkles on water, a sunset or a tree on a hill. In Liquid Diamonds, the sparkles on the transparent water are my focal point. I framed them with the trees and rocks.

LIQUID DIAMONDS
15" x 22" (38cm x 56cm)
Collection of the artist

We see this bird immediately because of the way we read, leading the eye into seeing more in the picture.

We see this bird quickly, but its location suggests flight or suspension in space.

TAKE ADVANTAGE OF HOW WE READ

Another way to view the picture space is in terms of quadrants, with each quadrant being a possible location for the center of interest. This method allows you to take advantage of how we read, that is, left to right, top to bottom, which influences the way we view a picture. We assume the beginning to be upper left and the conclusion to be lower right.

Our eyes delay moving to this quadrant. Locating the bird here suggests there is more to the story.

In this quadrant we feel as if we have come to the end of the story.

PICTURE FORMAT

This is probably the most forgotten aspect of composition, yet one that is fundamental to your treatment of the subject and its resulting impact. Format refers to the proportions (the lengths of the sides) of your picture and whether you use a horizontal rectangle or vertical rectangle. A vertical format causes the eye to move up and down and enhances feelings of growth, dignity and soaring. An exaggerated horizontal format improves the sense of distance and space. In this format, predominant horizontal lines emphasize calm or, if curving, rhythm and flow. Some artists believe the square format is boring; others see it as a challenge. Make up your own mind.

1

EXPRESSION CHANGES WITH DIFFERENT FORMATS

These pictures illustrate how a subject's expression changes simply by choosing a different format. By taking the subject of Figure 1 and expressing it in a tall format (Figure 2), I created a vertical movement between the foreground and middle ground, that is, between the flowers and the building. The vertical shape also allowed me to say more about this old country schoolhouse, for it, too, is pushing up daisies. In Figure 4, the greater horizontal expanse allowed me to better express the flow and movement of the stream than in Figure 3.

2

3

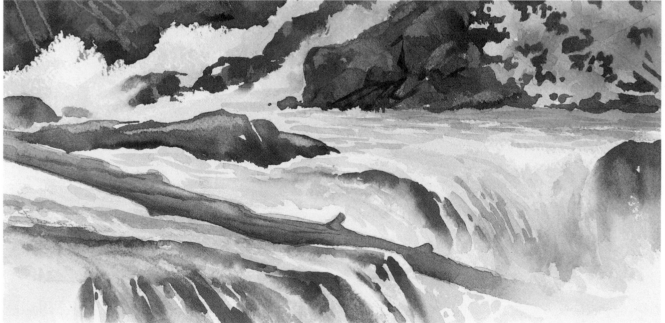

4

CLOSURE

Closure is the mental (usually subconscious) process of "finishing"—making connections between random bits of information to produce relevant meaning. The brain relies heavily on memory to identify things. For example, as you proceed through your daily life, you don't have to stop and examine every little detail that you encounter. You know from memory what your environment contains. You only slow down when your brain detects something unknown or different from the norm. At this point it switches from subconscious processing to conscious awareness until it can identify, process and file the new data for future reference.

With only a minimum number of clues (and memory), the brain jumps to conclusions. You only need to smell baking bread to know that it is there. When you see only part of an object, you take for granted the rest is there. The brain will make every effort to find some sort of meaning.

As humans, we take great pleasure in finding closure. Think of all the games, mystery stories, quizzes and puzzles there are. They entertain us by testing our abilities to find some hidden closure. It seems that the harder the problem, the greater the sense of accomplishment we experience in finding closure.

PLAYING MIND GAMES

Closure can work to your benefit when the viewer's mind completes an image. Strangely enough, with minimum clues the viewer's mind tends to complete the best image it can. The viewer, in turn, thinks that you are a wonderful artist. In other words, by painting less you paint better. An example of this is painting only part of a flower, leaving the rest to the imagination.

CLOSURE IS JUMPING TO CONCLUSIONS
What do you see in these two illustrations? If you see something other than the straight lines I have drawn, it is because your brain is jumping to conclusions in order to reach closure.

LACK OF CLOSURE IS FRUSTRATING
In this maze of lines there is a perfect five-pointed star. Can you find it? If you can, you are going to feel pretty good about yourself, because this is a tough one. You might feel frustrated and eventually want to look at the answer on page 72. Now if the answer was not there, you just might get a little more than cranky, because you might not have reached closure.

HOORAY FOR WATERCOLORS!

The soft subtleties of watercolors can create and suggest images that make use of closure. The fact that we can merely suggest images by using wet-in-wet or damp techniques is of immeasurable advantage when playing the closure game.

HOLDING THEIR ATTENTION

Billboards and road signs depend on instant closure in order to be functional. In fine art, however, we want delayed or multiple closures in order to hold the viewer's eye and interest as long as possible. The longer the eye lingers over a work, the more rewarding the closure feels. Viewers feel more a part of the work when there are more levels of meaning the mind can discover. If you have ever had someone say about one of your paintings, "Every time I look at it I see something different," then you are on the right track. If there is no room in your picture for viewers to reflect, contemplate or delve into what is before them, then they very quickly lose interest and stop seeing it.

Paintings rendered super-realistically run the risk of not leaving room for the viewer's imagination. A painting should speak of more than the artist's technical virtuosity. It should provide the viewer with essential information about the subject, in whatever detail the artist desires, but also leave room for the viewer's imagination.

SAY MORE BY PAINTING LESS
Closure allows you to say more by painting less. For example, you may need to paint a great number of the same objects in your picture, such as leaves on a tree or bricks on a wall. If you paint a few realistically, viewers can identify them and come to closure, assuming the rest are also realistic.

THE BRAIN GENERATES AN OUTLINE
Take a moment to stare at this face. The brain is so eager to see the complete face that it will generate a ghostly outline on its own.

SHAPES

Shapes are the building blocks of compositions. As such, their position, arrangement and characteristics play a vital role in our pictures. You may hear the subject, or positive shape, referred to as the *figure*. You may hear the background, or negative shapes, referred to as the *ground*. The term shape refers to both positive and negative areas. You may hear a large negative shape called a *passage* or *space*.

POSITIVE AND NEGATIVE SHAPES IN ACTION

In a picture, the ground (negative) is as important as the figure (positive). The role they play in relation to each other varies when a composition involves overlapping shapes. For example, the ferns (at right) are the positive figure against the negative background. In Figure b, the dark positive ferns now act also as the negative shape for the new positive foreground ferns. You can use this process of having one positive shape become the negative for another throughout your painting, primarily through value differences.

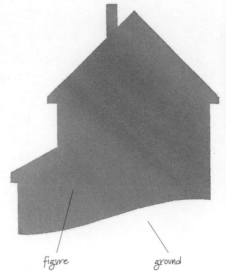

figure ground

FIGURE AND GROUND
Depending on how the viewer perceives them, sometimes the roles of the figure and ground change. Which is the figure? Which is the ground?

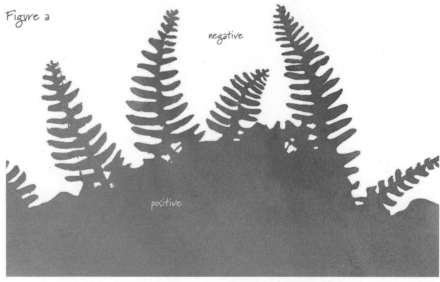

Figure a

negative

positive

tah-dah

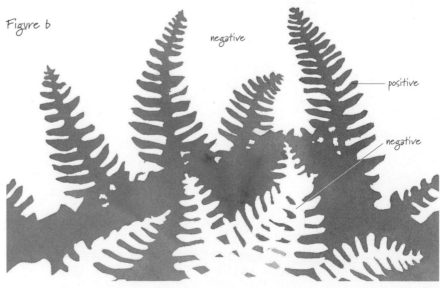

Figure b

negative

positive

negative

NEGATIVE PAINTING

This is the process of painting around an object to make it stand out in your composition. Because you do not use white or opaque colors to paint light-valued objects, you must learn to save them by painting the negative space next to them. Mind you, what might be the negative space for one shape may be a positive shape on its own.

Negative painting depends heavily upon closure (see page 77) for its effect. When you create objects by painting around them, you expect the viewer to identify those objects not by the paint you put down, but by the paint you do not. Not all negative painting uses the same rate of closure. By painting the complete contour (outline) of a flower you have immediate closure. By painting only parts of its contour you have delayed closure. By painting overlapping negative shapes you create multiple closure.

You, like many others, may find this process difficult to understand. You may believe that it requires some sort of optical gymnastics of which you are not capable, but you probably do it all the time and don't realize it. Every time you paint something dark behind something lighter, you are negative painting. For example, when you define the bricks in a wall by painting the lines between them, you are negative painting bricks. When you create fluffy white clouds in the sky by painting the darker blue sky areas, you are, in effect, painting the clouds in the negative. Once you understand how simple this process is, it will open doors to better and easier expression.

IS IT NEGATIVE OR POSITIVE? The negative space for one object may be a positive shape on its own.

immediate closure

delayed closure

WATCH OUT

Because of the layering usually involved with negative painting, it is advisable to use transparent or semi-transparent colors. If you wish to show numerous shapes that are to be farther and farther back in the picture, then:

• Use light to medium colors for each layer. If you go dark too quickly, it becomes difficult to show much depth in the work.

• Save only one or two shapes with each layer. If you start by saving all the shapes in the first layer, the spaces in between are so small that it becomes difficult to paint any other shapes of significance farther back.

multiple closure

GENERALITIES WITH NEGATIVE PAINTING

- There are many variations in negative painting.
- Apply negative painting in stages, allowing the paint to dry in between stages. With each successive layer, you add new shapes and values to the work.
- The color you use to paint around a shape will be the underlying color of the next shape you define in the background.
- You can lightly pencil in shapes so you do not become lost in the process.
- You may proceed with the painting at your own speed. There is no need to rush except when you might want to pull off (fade out) an edge before it dries.
- You can use negative painting at any stage of a work. You may wish to begin your painting by saving (painting around) important white areas, or you can use negative painting later on top of a previously painted passage.
- How far you extend the paint beyond the shape you are saving is your choice. It could go a small distance or fill the remainder of the paper.
- As shown on page 73, you can vary the amount of contour you paint.
- Negative painting will give your work a fresh, spontaneous look that is hard to achieve with masking.

1. WASH, SKETCH AND NEGATIVE PAINTING.
Here I started with a wash of Raw Sienna and Permanent Rose for my background. When this was dry, I sketched my flower and painted around it with a mix of the same colors. I faded this into the background with a damp brush.

2. MORE FLOWERS AND NEGATIVE PAINTING.
When the paint was dry, I sketched in two more flowers, then painted around them and the first flower with the same Permanent Rose and Raw Sienna mixture.

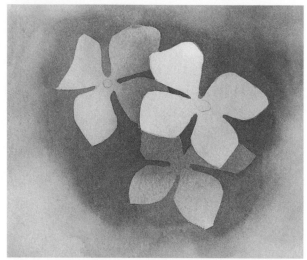

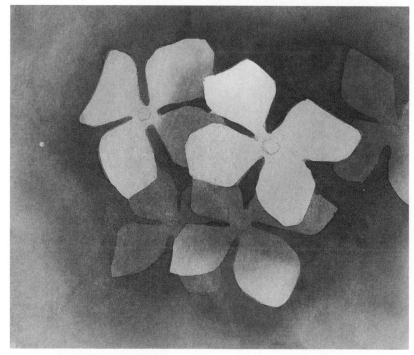

3. ALTER THE WASH MIX.
I repeated Step 2, but I began to alter the color by adding in a touch of Sap Green.

STEP BY STEP: FLOWERS WITH NEGATIVE PAINTING

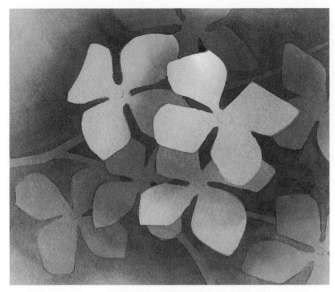

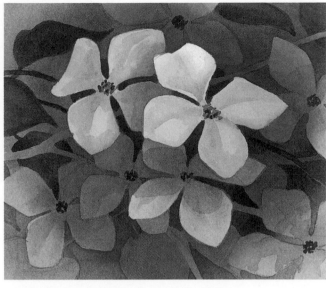

4. ADD MORE SHAPES, AND PAINT AROUND THEM.
When this was dry, I drew in some more flowers and limbs, then painted around all the shapes, adding more Sap Green.

5. MODEL DETAILS, SHADOWS AND BACKGROUND SHAPES.
I modeled the interior of the flowers with a pale Permanent Rose slightly dulled with Sap Green and the cast shadows with Permanent Rose cooled with Cobalt Blue. I also added some darker positive shapes in the background to balance the light shapes and suggest greater depth. Notice that these positive shapes are still the negative shapes for the flowers.

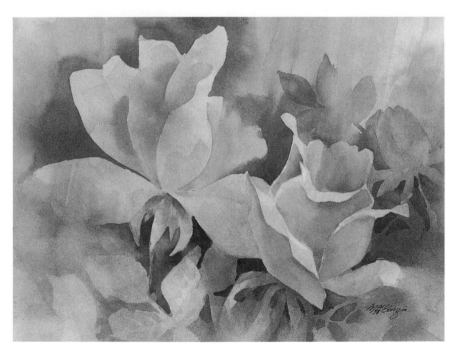

WHAT YOU NEED

watercolor paper
watercolor paints of your choice
- Raw Sienna
- Permanent Rose
- Sap Green
- Cobalt Blue
water
brushes of your choice

ROSE BUDS
11" x 14" (28cm x 36cm)
Collection of the artist

IMPRESSION AND MOOD OF BLOSSOMS
I used the same palette except with more Raw Sienna. Notice how you can create the appearance of flowers by only painting parts of the contours. Using this approach, it is so much easier to capture the impression and mood of blossoms. Notice also how the resulting hard and soft edges keep the eye moving and wondering what it's perceiving.

STEP BY STEP: ROCKS WITH NEGATIVE PAINTING

1. PAINT THE SHAPE OF THE AREA TO BE ROCKS.
After making a light sketch, I washed and spattered this area using a toothbrush, first with water, then with a variety of colors. To protect the part that was not rocks, I covered it with a cut paper stencil.

2. DELINEATE THE INDIVIDUAL ROCKS.
After the paint was dry, I laid out the individual rocks with pencil. I then painted the cracks between the rocks with a mixture of Cobalt Blue and Burnt Sienna. When I did this, I was, in effect, painting the negative space for each rock. In some places I faded the paint upward to produce shadow on the rocks. I faded the paint that defines the foreground rocks outward into the rocks behind. Then I let the paint dry.

3. REPEAT STEP 2 WITH A DARKER MIXTURE.
I used Cobalt Blue and Burnt Sienna, defining only the deeper parts of the cracks. Do some modeling on the foreground rocks.

4. DEFINE THE TOP EDGE AND CAST SHADOWS.
You can't see the effect of sunlight until a dark background defines the top edge and cast shadows are added. I also glazed the rocks in the middle ground to unify and separate them from those in the foreground.

WHAT YOU NEED

watercolor paper
pencil
watercolors of your choice
 • Cobalt Blue
 • Burnt Sienna
water
brushes of your choice
toothbrush
paper and scissors for making
 stencil

MANY TYPES OF NEGATIVE PAINTING
I used negative painting in many parts of this field sketch of a waterfall. The dark rocks define the white foam of the falls and the trees to either side. The dark water at the bottom indicates the limit of the foam. Within the water itself, pale blue and green shapes define the white surging foam. In the background, a medium value area is the negative shape that defines the top of the falls. When this dried, darker negative shapes were painted in it to suggest tree trunks.

STEP BY STEP: HILLS WITH NEGATIVE PAINTING

1. PAINT GRADED HILL SHAPES.
I first painted a passage grading from blue to green to yellow-green in the shape of the hills I wanted. I let this dry.

2. PAINT THE NEGATIVE SPACES WITH A SPONGE.
Using a dark middle green and a torn sponge (see page 29), I painted in the negative spaces between the clumps of trees. I painted only small areas at a time, then faded these upward. I worked from the top of the hill to the bottom.

WHAT YOU NEED

watercolor paper
watercolors of your choice
water
brushes of your choice
torn sponge

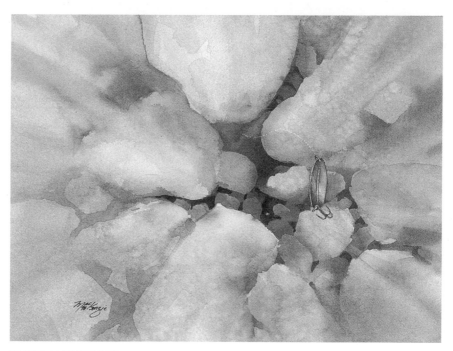

BURIED TREASURE
11" x 14" (28cm x 36cm)
Collection of the artist

NEGATIVE PAINTING AND CLOSURE
This underwater scene started with a loose, all-over wash of Red Rose, Raw Sienna and Sap Green. When this was dry, I created the rocks by painting in the negative spaces between them. Then, while it was still wet, I wiped back areas with a damp hog hair brush. Successive layers focused on darkening the area near the center of interest by defining more small rocks within negative spaces painted earlier. Even though I did not completely define each rock, viewers will mentally "complete" rocks and understand what they see.

LINES AND EDGES OF SHAPES

A line is a continuous mark that leads the viewer's eye through a work of art. The edge of a shape or boundary between two areas is also considered a line.

Try to make the edges of objects as interesting as the detail you put inside them. In fact, the edge is an extension of the surface treatment and should tell the viewer how the surface feels.

Our eye follows lines and edges and is attracted to anything that interrupts the flow, i.e., intersections, branching, breaks, sharp corners, etc. Since the eye is drawn to these places pay close attention when painting them, e.g. If you are painting tree branches and fail to connect them all it is very noticeable because there are breaks in the flow of the branches. If you are painting flowers pay attention to the valleys between petals and their tips because this is where the eye goes.

Which tree has rough bark?

Tips of petals and valleys between them are the most important parts of their contours.

POINT OF VIEW AND SHAPES

An object can be viewed from many directions. Try to pick an angle that tells the viewer as much as possible about the object by the edge detail.

What is it?

SHAPES CAN IMPLY FEELINGS

From the contour (outline) of a shape alone, you can suggest feeling. We read sharp, pointy shapes as hard and dangerous (probably from experience) and smooth, rounded shapes as safe and soft.

Which plant appears more dangerous to touch?

no angled lines = calm some angled lines = some energy many angled lines = much energy

SHAPES CAN SUGGEST ENERGY

Edges that are parallel to the frame (horizontal or vertical) suggest calm and stability, while those positioned at an angle suggest drama, energy and movement. Use diagonal lines (edges) to add life to your work. One way to do this is to choose a dynamic point of view for your subject.

CLASSIFYING SHAPES

You can classify shapes as geometric or free-form. Geometric shapes suggest a sense of order, precision and predictability, while free-form shapes suggest informality, relaxation and freedom. You also can classify shapes as either natural (sometimes called organic) or human made. Natural geometric shapes include honeycombs, crystals and grapes. Natural free-form shapes include clouds, trees, puddles, fruits, vegetables and people. Human-made geometric shapes include buildings, railroad cars, towers and bridges. Human-made free-form shapes include pop bottles, autos, clothes, shoes and hand tools.

IMPLICATIONS FOR PICTURE MAKING

The type of shapes you select for your work is important. Selecting shapes that are all of the same type—for example, natural free-forms (such as certain types of flowers)—will add to the sense of unity in your work. You can achieve contrast in this type of work primarily through value, color or pattern. However, if you mix two types of shapes, you can create more interest and contrast for a focal point. Let's say your composition consists primarily of natural free-forms (e.g., flowers). You can create contrast by introducing natural geometric shapes (e.g., circular flower centers, berries), human-made free-forms (e.g., vase, basket) or a human-made structure (e.g., the bench in *Harold's Bench*).

HAROLD'S BENCH
15" x 22" (38cm x 56cm)
Private collection

WHAT DOES YOUR COMPOSITION NEED?

Inject creativity into your plan by making changes to strengthen the composition. Change things from what they appear to be to what they need to be for a good composition. You may need to enlarge or emphasize elements. You may need to change your colors, point of view, time of day, etc., to create the effect you want. Translation of the subject makes you part of the work.

SHAPES OFTEN SUGGEST A DIRECTION

Shapes have a directional aspect that helps generate movement and point the way for the viewer's eye. Triangular shapes, such as the shapes of the boats shown, can lead the viewer's eye in a particular direction. A picture containing figures or faces causes the viewer to look in the direction that bodies, heads, faces or eyes are looking. Objects that have a "face" or "front" side direct the viewer's gaze in a particular direction.

one direction = uniformity, monotony

multiple directions = variety, chaos

Eyes follow implied direction.

INTERPRETING DIRECTION OF PEOPLE

How we read the direction of the human figure depends on the distance we are away from it. When a figure is far away, we read the shape of the whole body. As it comes closer, we read the direction of the head (particularly the nose), then the whole face and eventually the eyes.

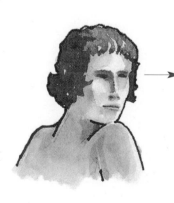

body

head

face

eyes

REPETITION, PATTERN AND RHYTHM OF SHAPES

Repetition and pattern strongly attract the eye, particularly if there are strong contrasts. Rhythm is the regular repetition of any of the elements of a design, with or without periodic alteration. However, the viewer can lose interest quickly if there is no variety. For example, repeated similar shapes can create unity and rhythm in a composition, but you should avoid monotony by introducing variety within the shapes. The eye stops seeing repeated shapes that are too similar.

GROUPING SHAPES

By grouping shapes together you can create a compound shape that is more interesting to look at. This also creates a sense of cohesion in the composition.

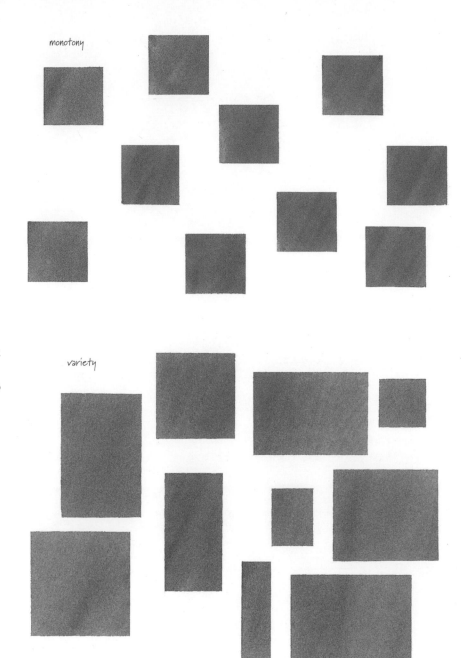

monotony

variety

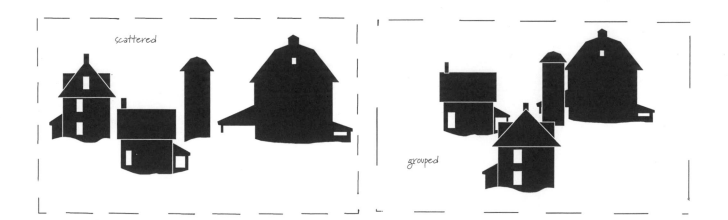

scattered

grouped

LEADING THE EYE WITH SHAPES AND EDGES

The arrangement of shapes can lead the eye like stepping-stones. Light-colored shapes attract the eye more than darks, so, if possible, make the stepping-stones light for the best results.

Clearly defined edges of shapes are called *hard edges*. Edges that fade out are *soft edges*. Hard edges take visual priority over soft edges because they provide something on which the eye can focus. Soft edges allow the eye to move freely.

In watercolors, soft edges are extremely easy to make, and they offer visual mystery and excitement to a work. Think of hard edges as a trap for the eye. Hard edges attract the eye as it moves over a work and lead it wherever the edge goes. A soft edge, however, is like a gate that allows the eye to move freely between shapes as well as in and out of the picture space.

a path for the eye

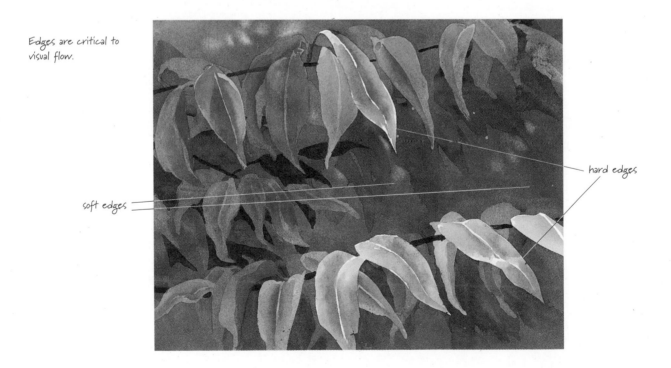

Edges are critical to visual flow.

soft edges

hard edges

MOVEMENT

Movement attracts our attention. Visual response to movement is a primary defense mechanism: Our eyes go to anything that moves so we can determine its significance.

ON TIME CARTAGE
11" x 14" (28cm x 36cm)
Collection of the artist

MOVEMENT WITH LINES AND SHAPES

On Time Cartage and Flight suggest movement, which attracts attention, with lines and shapes. Diagonals (wheels, roofline, butterfly wings) suggest movement and energy. Lines and shapes that are parallel to the frame are static. Suspended objects (trucks, parcels and butterfly) also suggest movement. In On Time Cartage, black outlines emphasize the edges of shapes more than usual. In Flight, lines and patterns on the butterfly wings attract attention. The hard edges of the butterfly take priority over the soft background where the eye is free to roam. The hard edges of the tiny twig area cause the eye to stop before it returns to the butterfly.

FLIGHT
11" x 14" (28cm x 36cm)
Collection of the artist

VALUES

Values are lights and darks. Light values, sometimes called tints, are high key. Dark values, sometimes called shades, are low key. Middle values are middle key. These key levels measure the amount of light falling on the subject.

In transparent watercolors, you make light values, or tints, by adding water. Light values have a quiet, ethereal effect, lacking eye-grabbing appeal unless they are next to something darker.

You can make dark values, or shades, by adding black. You can add Indigo, Sepia or Payne's Gray to darken a color. However, you must be careful that the blues and browns contained within these colors do not muddy or shift your color too dramatically. Dark values suggest strength, weight, solidity, mystery and dignity. However, a composition with too many dark values can be oppressive unless it is balanced with lighter values.

USE CONTRAST FOR YOUR FOCAL POINT

Through contrasting values we are best able to interpret our world—color differences alone do not do it. Therefore, objects and areas that you want the viewer to notice must have different values. The eye goes to the strongest value contrast, so save it for the focal point.

Nature uses a lack of value contrast to hide many of its creatures. We call it camouflage. Even though a creature may be a different color than its surroundings, if its value is about the same it will go unnoticed. Unless you plan to paint camouflage, you must use contrast. If you want the viewer to read your picture easily you must give adjoining shapes contrasting values.

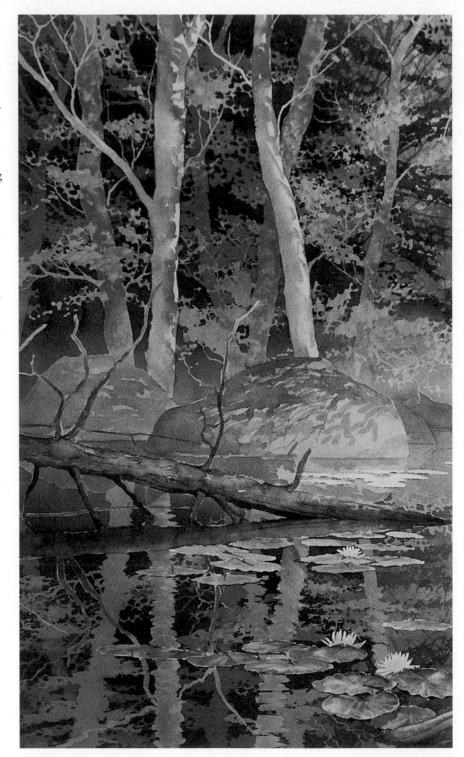

MUTED COLORS FOR SUBDUED LIGHTING
River Diamonds portrays a hazy, subdued lighting that is reflected in the muted colors used. The colors appear natural but are actually the product of Red Rose Deep and Sap Green (complements), with only the slightest help from some Cobalt Blue. Note the maroon shadows on the trees.

RIVER DIAMONDS, DETAIL
11" x 14" (28cm x 36cm)
Collection of the artist

DEVELOP MOOD WITH VALUE DOMINANCE

Allowing one value (light, middle or dark) to dominate your painting can play a role in developing mood and visual impact. Low-key paintings dominated by darks have a dramatic, mood-setting effect, conveying things we sense about darkness, such as mystery, intrigue, fear or sanctuary. However, a low-key painting also can appear overworked and oppressive, depending on the colors.

High-key paintings dominated by pale colors give the appearance of being bathed in light, setting a more ethereal mood. They can suggest optimism, clarity and life, but there is the danger of appearing weak, vague, washed out and trivial.

Most paintings are middle value because they offer the widest range of possibilities. You can have ominous drama contrasted with light cheerfulness in the same painting.

VALUE VARIATIONS SHOWING VALUE DOMINANCE

 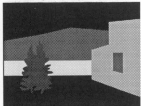

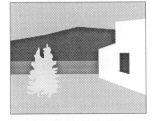

HIGH KEY
Lights dominate, with no extreme darks. Only white, light and two mediums used.

MIDDLE KEY
Middle values are dominant. White, light, medium and dark used.

LOW KEY
Darks dominate, with all values, including extreme dark, used.

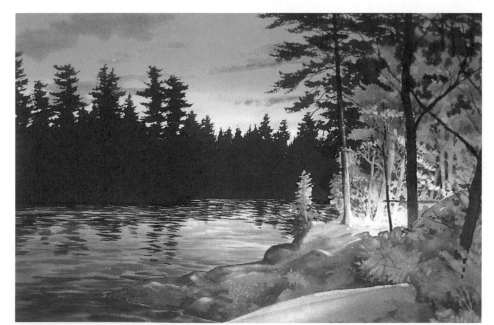

STAR LIGHT, STAR BRIGHT
11" x 14" (28cm x 36cm)
Collection of the artist

CENTER OF INTEREST AND CONTRASTS
In Star Light, Star Bright, the primary center of interest is the campfire light; the second is the light in the sky and the third is the reflected light in the lake. The clear northern air produces stark contrasts as night approaches, and we experience the last light of the day.

SUNLIGHT AND SKY LIGHT

On a clear day we see sunlight as white. Sky light is sunlight diffused by the atmosphere. It changes as the sky and atmosphere change due to such things as clouds, pollution and time of day.

TRANSLUCENT LIGHT

This is the light that passes through a semitransparent object, such as a leaf, flower petal, wave or thin ridge of snow. Translucent light tends to lighten and warm whatever it passes through.

REFLECTED LIGHT

This is light that bounces off one surface and back onto another. Like sky light, you only see this soft light when it strikes in a darker, shadowed area. Reflected light also picks up some of the color of the surface from which it reflects. In landscapes, this light is usually warm because of the earth colors of the natural surfaces and objects that reflect it.

LOCAL SHADOWS

This is the shading on the object itself that gives form to a flat shape. You can produce a shadow color by mixing the local color with blue (sky light) and a touch of its complement or gray. Each produces a darker, cool, slightly dulled local color. Warm reflected light also influences local shadows.

CAST SHADOWS

Mix cast shadows the same as local shadows, but be aware that because sky light influences them more than reflected light, they tend to be cooler. On a clear day, cast shadows on snow are bluish, like the sky. The darker you make cast shadows, the brighter the sun appears to shine. As atmospheric conditions change and sky light shifts color, so do the color, value and sharpness of cast shadows. They are darkest in areas where they are closest to the object casting the shadow.

EFFECT OF SKY LIGHT IN SHADOWS

For sunny days, add clean blue to your shadows. On dull days, add cool gray. On curved surfaces I also use a hint of cool sky color as a transition between the sunlight area and the darkest shaded side of the object.

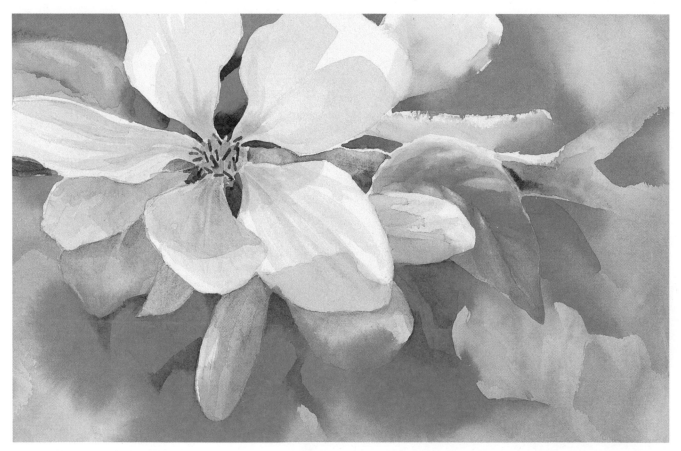

WARM AND COOL SHADOWS
These apple blossoms illustrate the role of warm and cool shadows in creating the appearance of light.

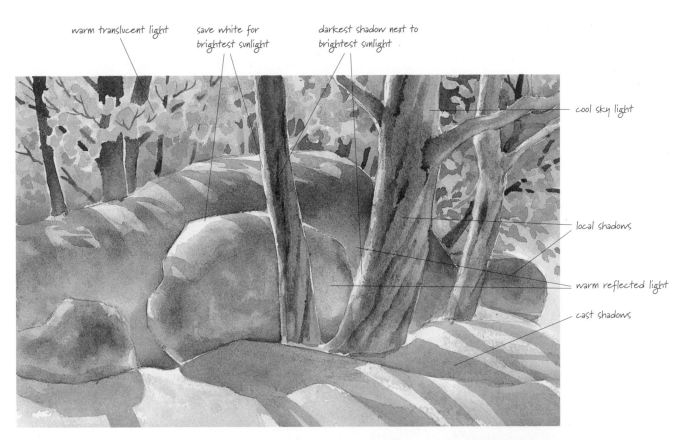

warm translucent light

save white for brightest sunlight

darkest shadow next to brightest sunlight

cool sky light

local shadows

warm reflected light

cast shadows

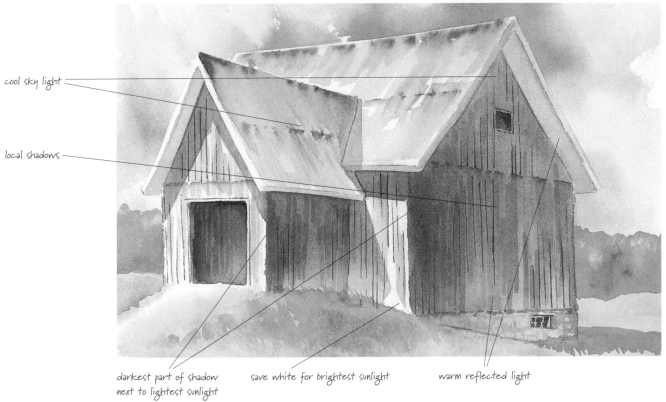

cool sky light

local shadows

darkest part of shadow next to lightest sunlight

save white for brightest sunlight

warm reflected light

DETERMINE DIRECTION OF CAST SHADOWS

The direction of a light source determines the direction of cast shadows. With one or two objects, determining the direction of shadows is not usually a problem. With multiple objects—such as tree trunks, fence posts, people, etc.—painting individual shadows properly can be a problem. You can solve this problem by using one-point perspective, with the sun or light source as the vanishing point. Base the location of cast shadows on lines drawn between the sun (the vanishing point placed well outside the picture space) and the base of the object. Undulations in the ground and tilted objects cause variations in shadows. Converging lines also lead viewers' eyes into the picture by creating the appearance of distance.

BACKLIT TREES

Draw two lines between the sun (vanishing point) and the outer points at the base of each tree. Extend those lines past the tree and off the page. If the sun is anywhere in front of you and the trees, or to your front left or right, the shadows will be between those lines on "this" side of the trees.

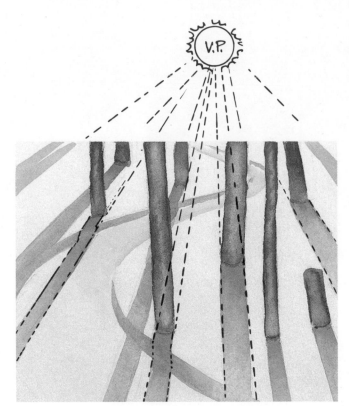

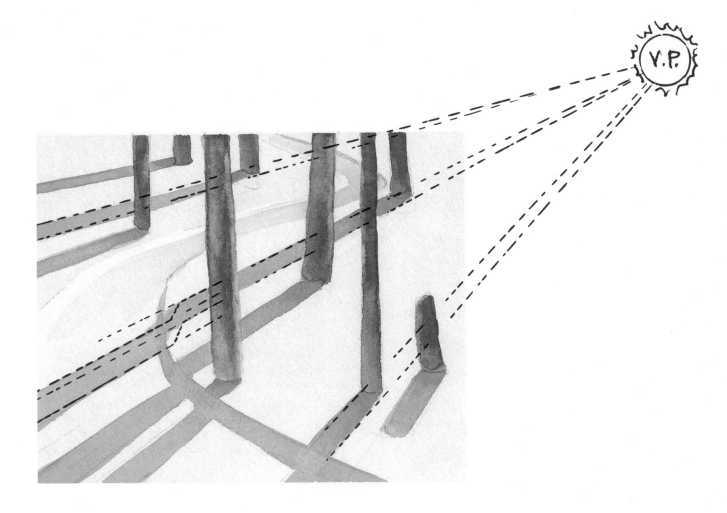

A DIFFERENT TIME OF DAY

These illustrations show the sun behind you or to your back left or right. In this case, you want the shadows to point toward the vanishing point. Again, draw in lines between the vanishing point and the outer points of the tree bases. Now the shadows are between these lines on the far side of the trees.

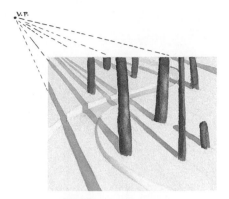
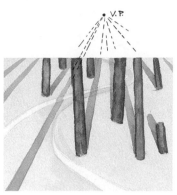

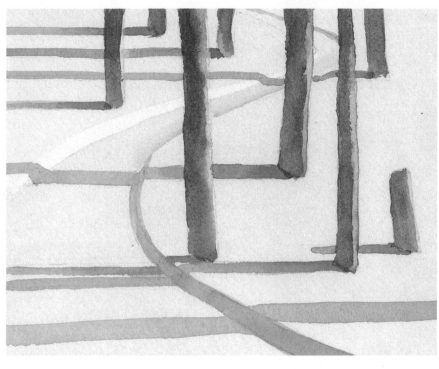

THERE IS ALWAYS AN EXCEPTION

When the sun is directly to the side and the shadows run across in front of you, they sometimes appear to be parallel.

SHADOWS DEFINE AND MODEL LAND

A flat brush is easier to use than a round brush for varying the width of these shadow lines as they follow the surface.

STEP BY STEP: SEEING AND RECORDING VALUES

In the process of recording and manipulating values in thumbnail sketches (small, rough sketches), you are really working on two problems. The first is determining value dominance for the whole scene. This will influence the mood and impact of your final picture. Second, you want to identify and manipulate the value contrasts between specific areas and objects in your scene so your final picture is easy to read.

By squinting at your sketch and your scene you can see where value difference is not enough to make one shape distinguishable from another. Darkening or lightening one or the other where they interface will solve the problem. By working out these value contrasts in a thumbnail you will save a lot of "adjustments" to your painting later.

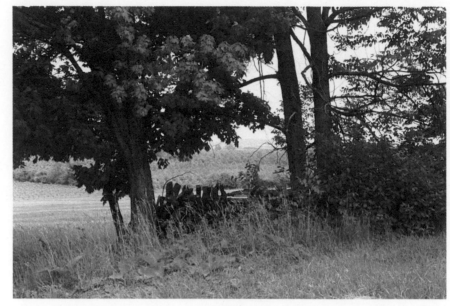

1. IDENTIFY LIGHT, MEDIUM AND DARK VALUES.
Keep it simple. Squint at your subject. In this case, my subject is a view on St. Joseph Island. Identify only the light (including white), middle and dark (including black) value masses.

2. LIGHTLY DRAW CONTOURS.
Record only the general outline of these shapes with light pencil. Later you will make value variations within each of these as you refine the shape. Indicate the direction of the sun.

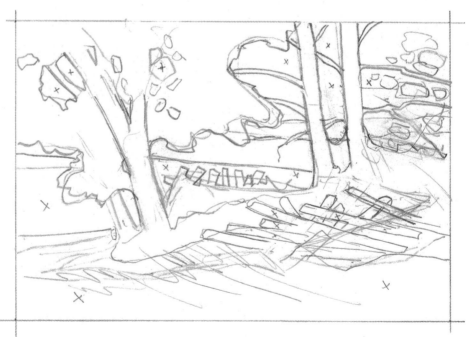

WHAT YOU NEED

white paper
pencil

3. LOCATE AND RECORD VALUE SHAPES.
Next, study and record the shape and location of contrasting values that intrude upon these large masses. This is the time to pay attention to the edges of these shapes, because they are most important in creating interest and dynamics within the work. Make any changes to the edges that you feel will help. Shapes do not exist in isolation. Like a jigsaw puzzle, each piece interlocks and interacts with its counterpart to create a whole. At any given time, a positive shape can become the negative shape for another (see page 72). Indicate with an X where the strongest light will be.

4. ADD THE LIGHT, MIDDLE AND DARK VALUES.

Consider the location of the strongest value contrast. This will have the greatest attraction for the viewer's eye and be a focal point. Save the lightest light (white paper) and the darkest dark for this contrast. As is often the case, the values of a mass will vary slightly across its surfaces (gradation), or it will have edges that vary—from hard to soft, light to dark. In your sketch you will invariably have to make value adjustments to some masses in order to achieve sufficient contrast, even though this may be contrary to the reality of the subject being viewed. You have a license to do this.

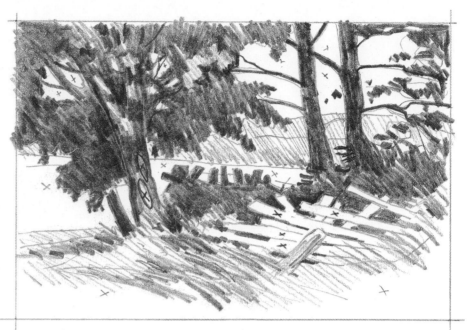

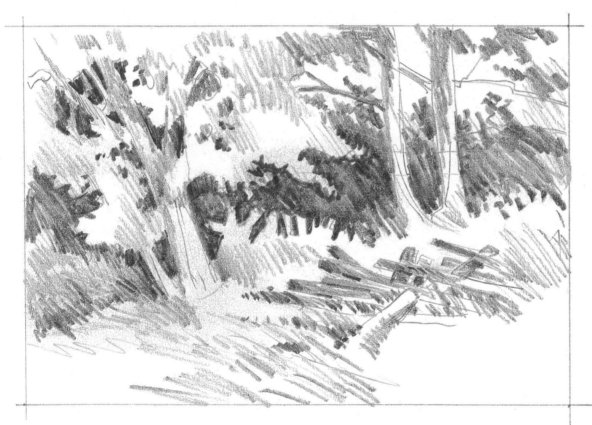

5. REVERSE OR REARRANGE VALUES.

At some point you will need to choose the dominant value for your picture. You can either make adjustments to your present sketch or redraw it. I strongly suggest that you redo your sketch anyway, so you can at least see the effects of reversing or rearranging the values. This can have a dramatic effect on an otherwise mediocre composition.

STEP BY STEP: PAINTING LIGHT AND SHADOW ON FOLIAGE

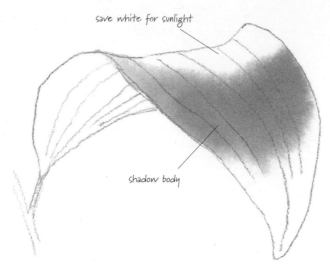

save white for sunlight

shadow body

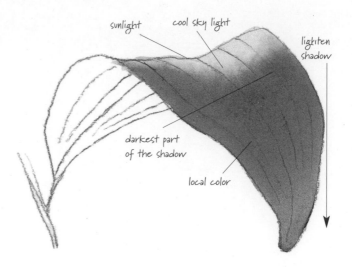

sunlight

cool sky light

lighten shadow

darkest part of the shadow

local color

1. APPLY SHADOW WET-IN-WET.
Wet the front face of the leaf. While still wet, apply the shadow body across the upper part of the face. This will diffuse in the water, so make sure you are far enough back from the top edge so it can remain white for the sunlit area. I used a concentrated mixture of Sap Green (local color) and Phthalo Blue (sky light), in addition to a touch of Permanent Rose to dull it.

2. APPLY BOTTOM PART OF SHADOW.
Immediately apply a second stroke of concentrated Sap Green to the bottom part of the shadow body, and fade this out toward the leaf tip. Warm the Sap Green near the tip with Raw Sienna, being careful to keep this area lighter than the shadow body above it.

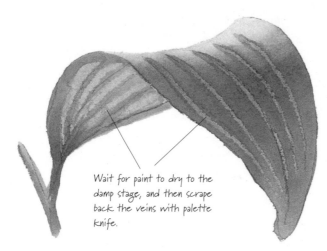

Wait for paint to dry to the damp stage, and then scrape back the veins with palette knife.

3. SCRAPE IN VEINS, AND PAINT UNDERSIDE.
When the paint gets to the damp stage, scrape in veins with a stiff palette knife. Now paint in the translucent light of the underside of the leaf with concentrated yellow-green (Sap Green plus Indian Yellow or Phthalo Yellow-Green). Grade this so it is darkest near the stem. When damp, scrape in the underside veins with a palette knife.

WHAT YOU NEED

pencil
watercolor paper
water
brushes of your choice
watercolors
- Sap Green
- Phthalo Blue
- Permanent Rose
- Raw Sienna
- Indian Yellow or Phthalo Yellow-Green
stiff palette knife
craft knife

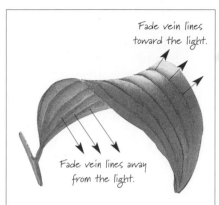

Fade vein lines toward the light.

Fade vein lines away from the light.

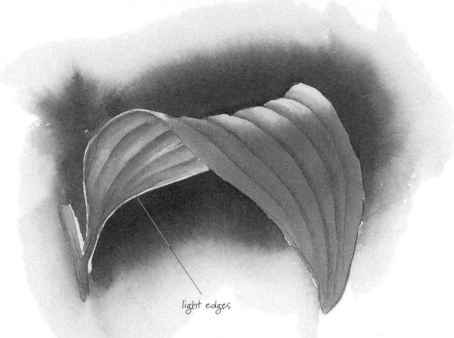

light edges

VARIATION ON STEP 3: ALTERNATIVE VEINING

Let the paint dry on the face of the leaf from Step 2. To paint the veins on the top face of the leaf (direct sunlight or sky light), use some of the concentrated mixture from Step 1. Paint the individual vein lines with a small (no. 4) brush, and as you paint each line, immediately fade it out to one side using another small damp brush. Fade the lines upward or toward the light. For the translucent light (light passing through the leaf), repeat this process but use concentrated Sap Green as the color, and fade each line downward or away from the light.

4. COMPLETE WITH A DARK BACKGROUND.

A dark background is essential to complete the appearance of sunlight and back-lighting. Notice how the light edges around the translucent light area can help suggest strong sunlight hitting the back side of the leaf. You can either leave them white or scrape them in with the tip of a craft knife.

VARIATION

On a white petal, use cool gray on the upper part of the face shadow. Blend to warm gray in the middle, then fade out near the tip, using Raw Sienna to warm the translucent light. Paint the veins with concentrated blue-gray on top and warm gray underneath.

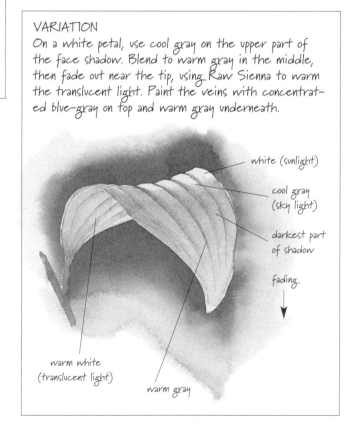

white (sunlight)

cool gray (sky light)

darkest part of shadow

fading

warm white (translucent light)

warm gray

COLOR AND THE COLOR WHEEL

Color is the element that best expresses the emotional aspect of a subject and the mood of the artist. A color's *hue* is the name of the color in its purest and simplest form—red, blue, green, yellow, etc. These are the colors of the spectrum and best describe their location on the color wheel.

Purity or *intensity* is the brilliance or chroma saturation of a hue. Colors are at their purest as found in the color spectrum (the color wheel). You can lessen a color's purity, or dull it, by adding varying amounts of its complementary color. The right amount will produce a form of gray. You will not find unsaturated colors—such as browns (oxides), Indigo, Sepia, Yellow Ochre or Phthalo Yellow-Green—on the chromatic color wheel.

Vivid hues have a powerful, full-volume personality. Reserve these for your center of interest. Be careful. The eye tires of these quickly, and too many vivid hues can cause confusion in your work. Dulled hues are less attractive to the eye but tend to reduce tension in a work. Their quiet, dreamlike quality sets a meditative mood. However, too many vague, dulled colors can make a work appear uninteresting unless they are countered by samples of pure color.

Temperature is the psychological suggestion of warmth or coolness inherent to the color. On the color wheel (page 95), the side containing red, red-orange, orange, yellow-orange and yellow is the warm family. The other side—violet, blue-violet, blue, blue-green and green—is the cool family. Red-orange and blue-green are the warmest and coolest.

Almost any color can be relatively warm or cool compared to another color. For example, if red-violet is next to blue-violet, it will appear warm. But red-violet next to a red-orange appears cool.

Colors have warmer and cooler versions. Red becomes warmer by adding a small amount of orange or yellow and cooler by adding a small amount of violet or blue. Therefore, it is possible to have warm blues and cool reds. Warm hues attract our attention, excite our emotions and give the feeling of action. Their brash, cheerful exuberance jumps out of the picture at us. Cool hues are refreshing, relaxing and clean. Violets can be moody, but too much of any of them can be depressive or gloomy.

VALUES AND PAINT SELECTION

To maintain clarity and freshness in dark color mixtures, make sure you use only transparent and semitransparent colors (see page 13). In watercolor, the term mud refers to colors that have lost their vibrancy due to mixing the wrong colors together, overmixing colors or overworking paints on your paper. In a dark mixture, any opaque or semiopaque color will invariably produce mud. Be particularly careful with Burnt Umber and Sepia. They readily muddy up and flatten any mixture. Reserve opaque and semiopaque colors for high- and middle-key pictures, where you can thin them and make them more luminous.

cool red

red

warm red

COLOR WHEEL

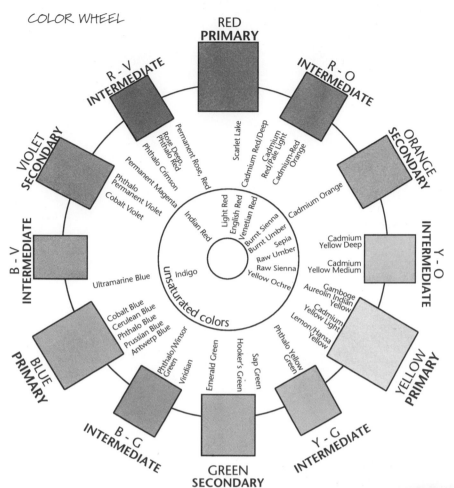

RED PRIMARY

R - O INTERMEDIATE

R - V INTERMEDIATE

ORANGE SECONDARY

VIOLET SECONDARY

Y - O INTERMEDIATE

B - V INTERMEDIATE

BLUE PRIMARY

YELLOW PRIMARY

B - G INTERMEDIATE

Y - G INTERMEDIATE

GREEN SECONDARY

Scarlet Lake
Cadmium Red/Deep
Cadmium Red/Pale Light
Cadmium-Red Orange
Cadmium Orange
Cadmium Yellow Deep
Cadmium Yellow Medium
Gamboge
Aureolin Indian Yellow
Cadmium Yellow Light
Lemon/Hansa Yellow
Phthalo Yellow Green
Sap Green
Hooker's Green
Emerald Green
Viridian
Phthalo/Winsor Green
Phthalo Blue
Prussian Blue
Antwerp Blue
Cobalt Blue
Cerulean Blue
Ultramarine Blue
Cobalt Violet
Phthalo Permanent Violet
Permanent Magenta
Phthalo Crimson
Rose Deep, Phthalo Red
Permanent Rose, Red

unsaturated colors

Light Red
English Red
Venetian Red
Burnt Sienna
Burnt Umber
Sepia
Raw Umber
Raw Sienna
Yellow Ochre
Indian Red
Indigo

TIP FOR EMPHASIZING A COLOR

You can emphasize a color by placing it next to a color with opposite characteristics, such as opposite hue, value, temperature and purity.

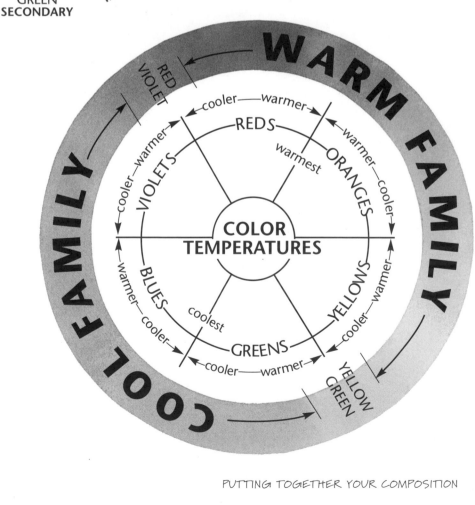

WARM FAMILY

COOL FAMILY

COLOR TEMPERATURES

RED VIOLET

REDS
cooler — warmer
ORANGES
warmer — cooler
warmest

VIOLETS
cooler — warmer

YELLOWS
cooler — warmer

BLUES
warmer — cooler
coolest

GREENS
cooler — warmer

YELLOW GREEN

SETTING UP YOUR PALETTE

The pigments you decide to work with are an individual choice. However, you should realize that setting up your palette is not simply a matter of putting out every pretty color you own. By limiting your palette, you will find that you will not only learn more about the nature of the pigments through mixing but you will save money as well. In addition, by limiting your color selection you are better able to achieve the unified results you want.

Pure colors attract more than dull ones, but color combinations have greater emotional appeal than individual colors. Use the following guidelines, as well your imagination and intuition, to choose color combinations that reflect your preferences and feelings—not necessarily what nature provides.

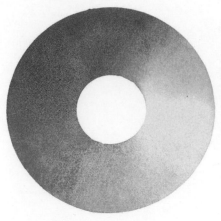

TRADITIONAL PALETTE
Cadmium Red or Scarlet Lake; Hansa, Lemon Yellow or Gamboge; Ultramarine Blue. Used by many artists. Pros: Low-staining; brilliant oranges. Cons: Dull greens and violets. Opacity of colors can produce muddy results if overmixed. It is best to dilute colors to avoid flatness.

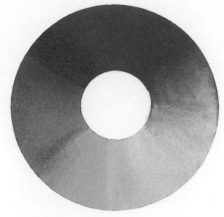

INTENSE PALETTE
Permanent Rose, Red Rose Deep or Phthalo Red; Phthalo Blue; Indian Yellow. Pros: Brilliant, transparent mixtures. Bold exciting results. Cons: Staining colors are hard to wipe back. Many may be too intense for your subject.

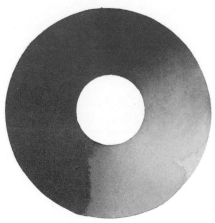

BLACKENED PALETTE
Indigo; Indian Yellow; Red Rose Deep or Permanent Rose. Pros: Extreme, luminous darks; transparent, bright lights. Cons: Indigo can overpower other colors. For best results, choose one that has a blue cast to it (for example, Winsor & Newton).

DELICATE OR HIGH-KEY PALETTE
Permanent Rose or Red Rose; Aureolin; Cobalt Blue. Pros: Transparent, nonstaining colors produce a great range of luminous mixes and grays. Cons: Extreme darks hard to produce. Viridian is a transparent, non-staining green often used with this triad.

WEATHERED (UNSATURATED) PALETTE
Indigo; Raw Sienna; Burnt Sienna, Light Red, English Red, Venetian Red or Indian Red; muted mixtures. Caution: If you use either Light, English, Venetian or Indian Red, take great care to dilute them in order to avoid muddy mixtures. You can mix strong darks. Cons: Greens are very dull. For best results, choose an Indigo that has a blue cast to it (for example, Winsor & Newton).

SETTING
UP YOUR
PALETTE
Start with warm
and cool versions
of each of the
primary colors.

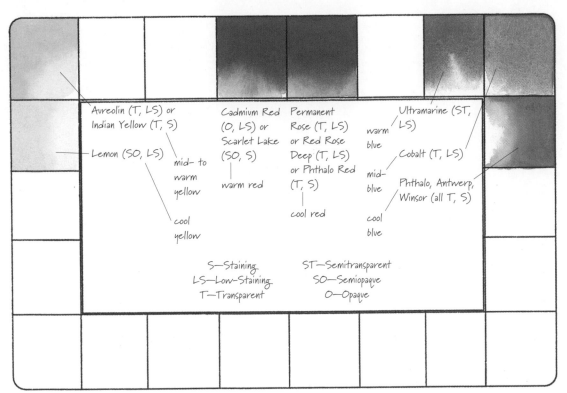

Aureolin (T, LS) or
Indian Yellow (T, S)

Lemon (SO, LS)

mid- to
warm
yellow

cool
yellow

Cadmium Red
(O, LS) or
Scarlet Lake
(SO, S)

warm red

Permanent
Rose (T, LS)
or Red Rose
Deep (T, LS)
or Phthalo Red
(T, S)

cool red

Ultramarine (ST,
LS)

warm
blue

Cobalt (T, LS)

mid-
blue

Phthalo, Antwerp,
Winsor (all T, S)

cool
blue

S—Staining
LS—Low-Staining
T—Transparent

ST—Semitransparent
SO—Semiopaque
O—Opaque

Start with warm and cool versions of each primary color.

CONVENIENCE
COLORS
IMPROVE
YOUR
SELECTION
Now add some
convenience col-
ors (colors you
don't have to mix)
to improve your
selection.

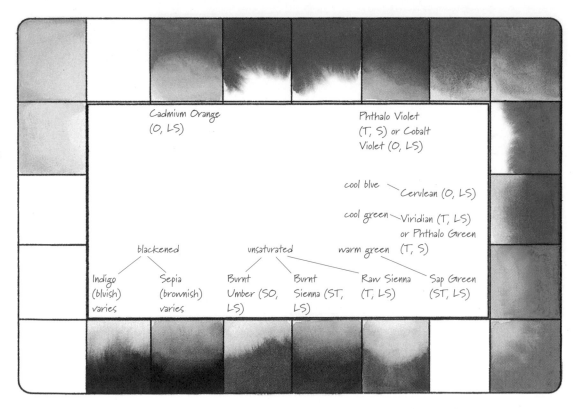

Cadmium Orange
(O, LS)

Phthalo Violet
(T, S) or Cobalt
Violet (O, LS)

cool blue — Cerulean (O, LS)

cool green — Viridian (T, LS)
or Phthalo Green

warm green — (T, S)

blackened

unsaturated

Indigo
(bluish)
varies

Sepia
(brownish)
varies

Burnt
Umber (SO,
LS)

Burnt
Sienna (ST,
LS)

Raw Sienna
(T, LS)

Sap Green
(ST, LS)

Now add a few convenience colors to improve your mixing range and triad selection.

COLOR HARMONY AND CONTRAST

Color harmony is the joint effect of two or more colors, or variations on a color, that appeals to our inner sense of rightness. It is something you can see and feel. Colors that are neighbors on the color wheel (analogous) have the potential to produce harmonious schemes. Analogous color schemes are expressive because they produce a particular mood or atmosphere in a picture.

You also can suggest harmony by balancing contrasting forces. That means using complements (colors opposite each other on the color wheel) and the resulting dulled colors they produce when mixed. Choosing a complementary scheme automatically gives the viewer a one-two punch. Not only are the hues in contrast, so are their temperatures.

TIPS FOR INCREASING COLOR HARMONY

You will increase the chance of color harmony if you limit the number of colors in your color scheme. Two or three colors are more than enough to produce a wide range of mixed colors. Stick with these selected colors. Many color schemes fall apart because the artist, for whatever reason, slowly starts introducing colors that were not in the original plan.

Choose one color to dominate the scheme and set the mood. We are talking here about one color that is used in varying forms in many areas of the work, and that is found in many of the color mixtures employed. We are not talking about a color you may choose for sharp contrast at the focal point.

Glazing a wash of transparent color over part or all of your painting has a unifying effect because it gives all existing colors something in common. The same is true if you tone your paper all over first with a wash of a particular color or temperature. This color will influence and harmonize all others placed on top of it.

harmony through similarity

harmony by balancing opposites

MAKE CHOICES THAT EXPRESS YOUR INTERPRETATION

Reproduction of what you see before you is often important to an artist, yet what you should really be after is an interpretation of what you see. Make choices about what to include, what to eliminate and what to modify to express the quality or message you see in the subject.

For example, if I were studying a butterfly, I would want to capture the essence of flight. If I were painting a tractor, I would concentrate on the feeling of strength. If I were painting an old tree, I would want to capture the rigors of time. If I were painting water, I would concentrate on fluidity. First impressions are the seeds for what is important.

COLOR SCHEMES

When you choose colors for your work, your plan or strategy is your color scheme. Harmonious color schemes contribute greatly to the sense of unity within a painting. I show some standard color schemes on pages 100–105, with these words of caution—do not take rules of color selection too seriously. Although beauty reflects order in many instances, you cannot reduce the creative process entirely to pure analytical formulas. Allow your intuition and personal preferences to lead you to your own personal color schemes.

A question rarely considered when developing a color scheme is, "When do I choose my colors?" In many cases, artists choose a subject, develop a sketch or composition and then decide what colors to use. Invariably, the colors chosen will represent the real-life, local colors of the objects in the plan and show few imaginative variations. Take the

time to experiment on a separate piece of paper. Find out how different color schemes work for you. Try all possible mixtures and proportions, and find out how these appear when you dilute them with water.

Develop a color scheme that represents a particular mood or captures an intriguing combination of pigments, then apply it to your subject of choice. You will invariably produce a work that is far more expressive of your feelings. In other words, use of local colors tends to block the imaginative use of color. This is one way around it.

You can find harmony in color relationships that emphasize both similarities and differences. Except for the monochromatic, the colors in each scheme have a logical, orderly relationship. See the color wheel on page 95 for specific colors for your scheme. Treat the unsaturated browns that are not on the color wheel as "dark oranges."

Phthalo Green

MONOCHROMATIC
You guarantee harmony with variations on one color, because it is impossible to have color conflict. Create contrast entirely through value differences.

ANALOGOUS

With three or four neighboring colors, you can easily achieve harmony and mood because of the close relationship of the colors. Mixtures invariably result in warm and cool versions of each color. Mixtures are also bright and clean because there is nothing to dull them. Achieve contrast primarily through value differences, not color.

Permanent Rose, Scarlet Lake and Cadmium Orange

COMPLEMENTARY

Opposite colors enhance each other with the greatest chromatic contrast possible. Dulled colors produced by mixing the two are harmonious because they contain some of each of the pure parent colors. Create additional contrast through value changes.

Sap Green and Permanent Rose

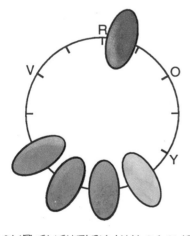

COMPLEMENTARY ANALOGOUS

You can add color and purity contrast to the harmony of the analogous scheme with a complementary color. A wide range of interesting grays can be produced by mixing or mingling the complementary color with the analogous colors.

Cobalt Blue, Phthalo Green and Sap Green vs. Cadmium Red

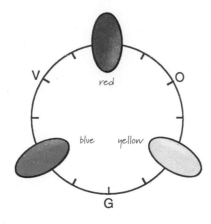

Intense Primary Triad
Phthalo Red, Indian
Yellow, Phthalo Blue

Delicate Primary
Triad
Permanent Rose,
Aureolin Yellow,
Cobalt Blue

Weathered
(Unsaturated) Triad
English or Venetian
Red, Raw Sienna,
Indigo

TRIADS

A triad is a combination of three hues in a triangular relationship on the wheel. Triads offer the widest range of unique color combinations. They also offer the best chance of producing "mud" when you mix too many colors together at once, or if one of the colors is opaque. You can achieve harmony by allowing one color to dominate and using only the other two colors for mixing with that color. Contrast is by color, value and purity.

PRIMARY TRIADS

These are the most versatile triads because you can (theoretically) mix all other colors from these three: red, yellow and blue. However, choosing primary colors is not just a matter of selecting any red, yellow and blue. In most cases, each of these hues has a bent toward being either warm or cool. The selection you make will determine the type and quality of colors they produce when mixed together.

Many artists like to have warm and cool versions of each of the primary colors on their palettes, so they can mix clean, brilliant colors. They start with the palette on the left and then add a selection of favorite convenient secondary, "unsaturated" and "blackened or whitened" pigments, if they wish.

The following are some primary triads that you may wish to consider.

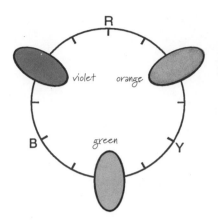

SECONDARY TRIADS

These are unusual triads made up of secondary colors. The results are not what you would think if you are new to mixing. Two primary colors make a secondary color, but two secondary colors do not make a primary. However, they do create a wonderful range of grays.

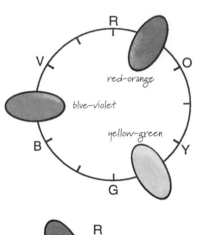

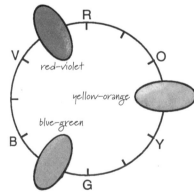

INTERMEDIATE TRIADS

As pure colors, these may be quite startling next to each other, but when mixed they produce extraordinary results. These are a challenge to use, but the expressive results are worth a try.

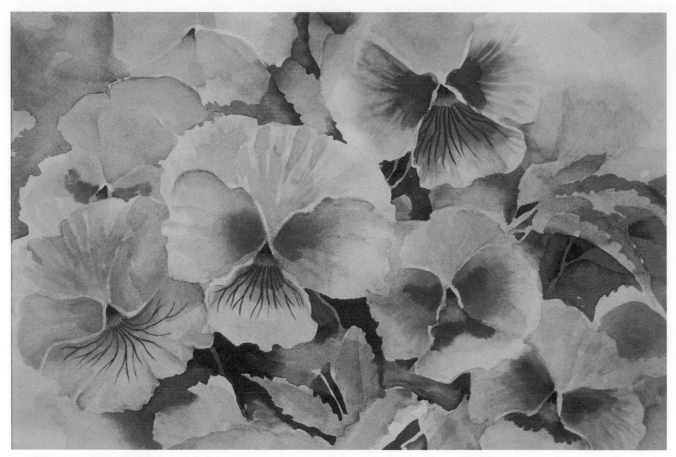

VARIETY AND HARMONY
In Pansies the repeated flowers create a random pattern with variety in the
color combinations. I made certain to clearly define the intersections of edges at
the center of each flower, as well as the edges of each petal.

 Pansies started as a loose wet-in-wet field of intermingling colors from
which the flowers developed. The gradation of colors resulting from the blend-
ing adds appeal to each flower. Warm and cool colors intermingle throughout the
flowers, creating a balanced harmony.

PANSIES
11" x 14" (28cm x 36cm)
Collection of the artist

A SIMPLE PRINCIPLE FOR CLEAN, BRILLIANT RESULTS

It is important to know the relative positions of the colors on the color wheel (see page 95). To mix a secondary or intermediate color that will have maximum brilliance, choose two colors that are as close as possible to the color you want to mix. For example, in Diagram A on page 105, I produced violet by mixing red and blue, but the degree of brilliance you achieve depends on which red and blue you choose. For maximum brilliance you must find a red and blue that both have a hint of each other in themselves. In this case, Ultramarine Blue contains a hint of red that warms it, and Permanent Rose contains a hint of blue that cools it.

 Another way to think of it is to look for two colors such that each contains a hint of the end result you are after. The farther away on the color wheel colors are from the color you want to mix, the duller the results will be. This is because as the colors you mix get farther away from the color you want to achieve, they invariably begin to contain hints of the target color's complement. See Diagram B on page 105.

GRADATION

In composition, gradation is a gradual transition from one color or value to another. Our eyes delight in gradations from one color to another.

DIAGRAM A: MIXING BRILLIANT SECONDARY COLORS

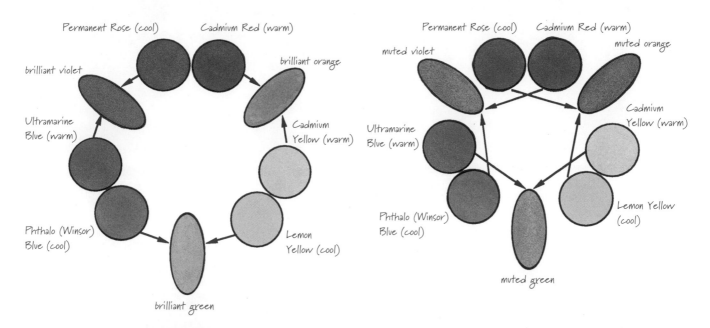

Permanent Rose (cool) Cadmium Red (warm)

brilliant violet brilliant orange

Ultramarine Blue (warm) Cadmium Yellow (warm)

Phthalo (Winsor) Blue (cool) Lemon Yellow (cool)

brilliant green

DIAGRAM B: MIXING MUTED (GRAYED) SECONDARY COLORS

Permanent Rose (cool) Cadmium Red (warm)

muted violet muted orange

Ultramarine Blue (warm) Cadmium Yellow (warm)

Phthalo (Winsor) Blue (cool) Lemon Yellow (cool)

muted green

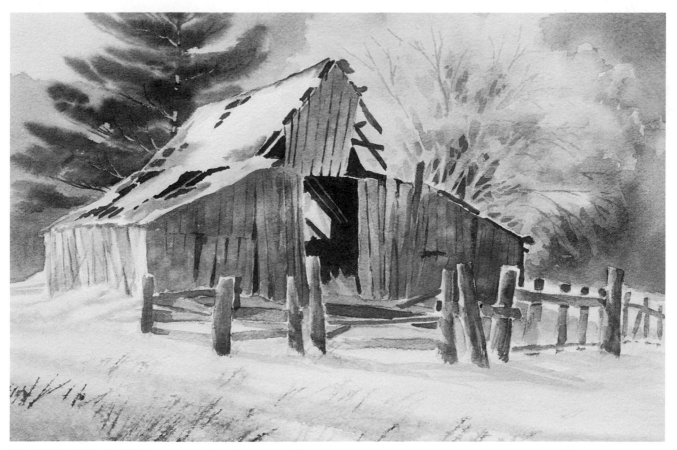

PATTERN AND GRADATION CREATE BALANCE

The barn boards and fence of Southwest Homestead create a pattern that has variety in size, position and spacing. Notice how the broken rafters and intersections in the fence attract your attention. The walls gain interest with a gradation from warm browns to cool gray. The warm wood, grass and tree against the cool snow, evergreen and sky provide a psychological balance.

SOUTHWEST HOMESTEAD
11" x 14" (28cm x 36cm)
Collection of the artist

Ways to Approach Composition

Everyone develops his or her own methods for tackling pictorial composition. On the following pages are three basic approaches that I use.

Approach One: Working From Real to "Abstract"

Most two-dimensional art is an "abstraction" to a certain degree, since it is only the representation of three-dimensional reality. This approach is what I use when I wish to make a picture about an existing subject, be it real (from life) or in a photograph.

Consider the subject or photo in front of you. Think about the elements and principles of composition as you know them, along with your intuitive sense of design, to decide how you will arrange the components into a pleasing composition as you see it.

KEEP OPTIONS OPEN WHEN USING REFERENCES

Though I never use someone else's painting for reference, you can learn from copying photos and others' work. However, when you gain control of the medium and an under-standing of composition, wean yourself from this method of picture making. Use photos, magazine pictures, slides, models, etc., only to develop ideas. Use whatever material you wish as a starting point but not for the end product. Develop a composition from several references or views of a subject to get the details you want. Take what you need to create an *interpretation*, but don't restrict yourself to literal translation. Until you make changes to your references, you cannot claim ownership to the picture. That's when the creative process begins and you can call yourself an artist.

Reference material can get in the way of painting. For example, committing to every detail of a photo is a sure way to stifle the nature of this medium. Even if you are working on a commission where a literal translation is necessary, try to leave some areas unplanned so you can innovate during the painting process. For most of my work, I put references aside and refer to them as little as possible once I have a sketch on my paper. This way, the painting surprises me with each stroke by developing on its own.

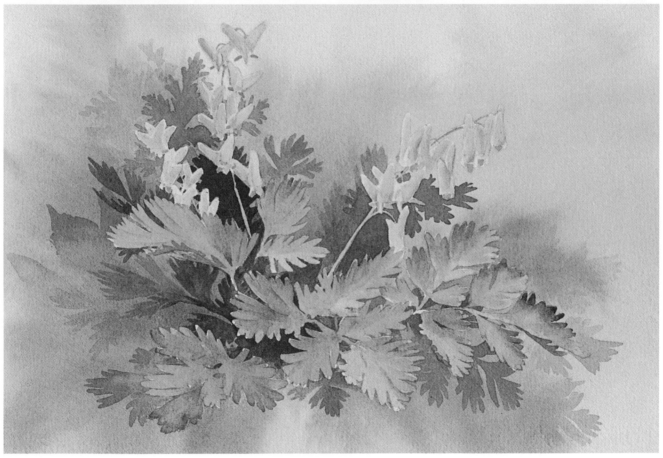

DUTCHMAN'S BREECHES

I often use more than one photograph for reference. In viewing the first one, I became interested in the way this delicate wildflower bore its blossoms, but I needed the second picture to define the laciness of its leaves. The important thing is that photos gave me the detail, but I created my own composition.

DUTCHMAN'S BREECHES
11" x 14" (28cm x 36cm)
Private collection

WHAT GRABS YOUR ATTENTION?

When you scan through photos or references, there are always those that grab your attention. Sometimes only a portion of a photo appeals to you. Something may elicit an emotional response, such as the colors, the lighting, a memory of a pleasant experience or a feeling you want to incorporate into your painting.

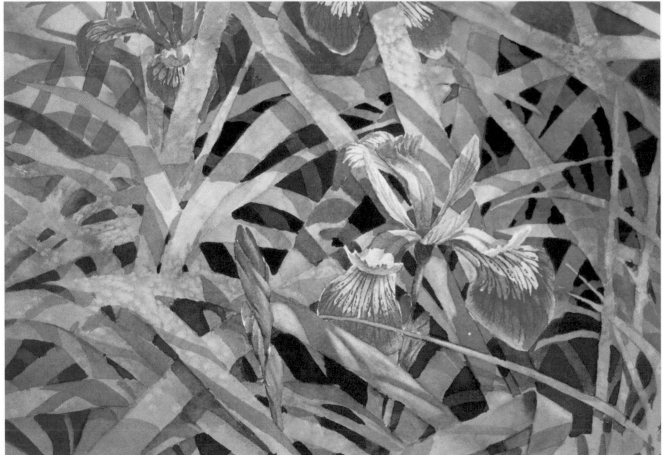

WILD FLAGS
This wild iris grows along the edges of lakes and bogs. In the photo, I became interested in the dense foliage that seems to head in every direction while almost cradling the flower. Using the photo, I created my own flower(s) and foliage arrangement.

WILD FLAGS
11" x 14" (28cm x 36cm)
Private collection

HOW ARE VISUAL ELEMENTS ARRANGED?

Next, determine how the visual elements in your reference—lines, shapes, colors, values, patterns, etc.—cause this emotional effect. What is the mood in the photo? What colors are evident? Where are the shapes? Can you see the value pattern when you squint?

Composition is about relationships, comparisons and contrasts, so look for these things in your photos. You need these answers, because they form the basis of your interpretation of the photos.

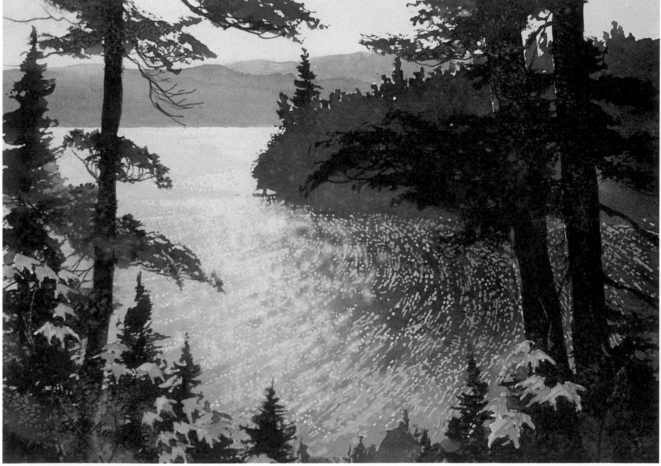

SHIMMERING LIGHT, PLEASANT MEMORY
It was the shimmering light on the water that attracted me here, as well as the pleasant memory of a park in which I had once camped. I added more foreground trees and emphasized the wind direction in the waves. I created the sparkle effect on the water by softening some of the dots of light that I had saved by masking.

POINT AT OSTLER LAKE
11" x 14" (28cm x 36cm)
Private collection

SKETCH VARIOUS IDEAS FOR COMPOSITIONS

Take what you want from your references. Alter and manipulate them to make the strongest statement. Make several thumbnail sketches until you arrive at a composition that best captures the appeal the reference material held for you.

HOLD YOUR HORSES

Only start sketching after you have taken the time to really look at and think about your subject. If possible, walk around and study it from different points of view. Don't rush right up to a subject and record everything that's before you. If you do, you probably will record a lot more than necessary, and you will record everything with equal importance.

Once you have begun to sketch, don't let the desire to get painting override the time you spend exploring compositional ideas and alternatives. Continue to look, sketch and think about your subject. Thumbnail sketches will give you a chance to experiment with the arrangement of shapes, values and lines. Remember, the first sketch you make usually is not the best solution or composition you can come up with, so make several before you decide which to do.

What is the value arrangement? Squinting will allow you to see the big value shapes. Identify the light (including white), middle and dark (including very dark) value areas. Remember that light (white) areas will attract viewers' attention in a composition, particularly when they contrast with the very dark darks. Outline major value shapes in a sketch.

What is the direction of the lighting? Since cast shadows usually are part of a realistic composition, you may want to change the direction of the light to improve the composition (you have artistic license to do this). Adjust values for contrast, for interest and to emphasize your focal point. Add detail. Redraw, if necessary. Transfer to watercolor paper.

SUMMER APARTMENTS
11" x 15"
(28cm x 38cm)
Collection of the artist

COMPOSING WITH A VIEWFINDER

A viewfinder is a piece of cardboard or plastic with a rectangular hole in the middle. Use it to frame a subject, scene or part of a photo to locate a composition. This eliminates peripheral detail so you can focus on the subject. Think about your subject and composition as you look through the viewfinder. Here are some considerations, in addition to others mentioned throughout this chapter, to help dissect your subject and guide you to a stronger composition:

What would make a good focal point? Is there enough contrast around it to emphasize your focal point? Will you need to create more contrast to emphasize your point of interest?

Would it help if you transformed something? For example, could you enlarge, distort or eliminate some aspect of the subject or scene? Is there something new you could introduce?

View the subject from different vantage points. Move up, down and behind the subject, if you can.

What format and proportions best suit the subject? Should it be horizontal or vertical?

TAKE THE TIME
You will never know if there was a better composition for your idea unless you make the effort to explore variations. I went through several before settling on one for Summer Apartments.

1. SEE THE BIG SHAPES AND VALUES.

The subject for this demonstration is an old railroad station on the Ontario Northland Railway line in Cobalt, Ontario. I see the station as a giant geometric mushroom offering protection beneath its massive top. I find the curving roof braces a wonderful contrast to the straight lines of the roof, while the shadow of the roof provides an opportunity for some great value contrasts. Analyze the station, looking for major lines dividing the subject. These are usually the edges of major value shapes, which you can read more easily if you squint. Think about lights, mediums and darks.

2. OUTLINE BIG VALUE SHAPES IN A SKETCH.

Also notice how smaller shapes relate to larger shapes. Think of changes in the arrangement that will produce a stronger composition. Keep in touch with what you would like as your center of interest—in this case, I chose the baggage wagon—and the values surrounding it that will enhance it. Eliminate what you feel is unnecessary, such as the picnic table. Note the direction of the light and where it falls on your subject. Mark these lights and sunlit areas with an X.

3. ADD VALUES TO YOUR SKETCH.

For my sketches I used a fountain pen with blue-black ink. To represent different values I varied the density of the hatch marks. A wet brush easily dissolved and spread the ink in each area to produce a wash in the value I wanted. I saved the X areas as white paper and made sure that the greatest contrast was still in the focal point area. Squint. Continue to study the smaller value areas of your composition, knowing that each needs to be lighter or darker than what is next to it in order for the viewer to see it. Don't be afraid to change the value of an area if it improves perception and value dominance.

4. ADD OR REARRANGE FOR MORE INTEREST.

I decided to add the lone figure as well as window detail, telephone pole (angled for character) and sundry freight. The figure became the major focal point, and the baggage wagon, secondary. At this stage I also added in the darkest values where needed. As is often the case at this stage, I needed to redo my sketch to clearly show the changes in subject matter, arrangements and values that I now wanted. I reminded myself that I was not working on a final solution but evolving toward one, and redrawing is part of that journey.

Now work up two or three other compositions that explore variations in value, subject arrangement and even style, because invariably it will be number two or three that you will like best of all. Remember, value patterns are the result of light direction. If you change the value pattern you are effectively changing the light source. Make sure that cast shadows are consistent with any new light source.

When you are satisfied with your sketch, transfer it to watercolor paper using as few light pencil lines as possible or very thin nonstaining paint. You can erase pencil lines later with a soft gum or synthetic eraser.

value and subject variation

subject and time-of-day variation

subject and style variation

Approach Two: Working From "Abstract" To Real

With this approach you allow your imagination and intuition, along with your knowledge of composition, to generate ideas. This time you do not start with a subject, view, time or place in mind but instead start with abstract sketches. Using additional free sketching, intuition and imagination you gradually move toward a real idea. The less you block your intuition in this process, the more easily it flows each time you use it. This approach is valuable when you are nowhere near a subject—on flights, in waiting rooms, in coffee shops, etc. All you need is a piece of paper and your imagination.

STEP ONE: DEVELOP ARRANGEMENTS IN THUMBNAIL SKETCHES

The first step in this process is to arrange shapes and lines in small abstract thumbnail sketches. From these come ideas for pictures which is step two. There is no right or wrong way to do this. Listen to your intuition as you decide where marks should go.

I will show you five variations on how to begin and complete this approach. You always start by putting down random marks in some particular way in your thumbnail sketches.

STEP TWO: WHAT COULD IT BE?

Examine your thumbnail sketches one at a time. Turn your imagination loose, and squint at each sketch. Ask yourself, "What could it be?" Turn the sketch and look at it from all angles, increasing the odds of seeing an idea you could develop.

EXPERIMENT WITH REDRAWING YOUR SKETCHES

You may add more lines or shading to your sketch. Let your mind make suggestions. Redraw sketches.

Clarify the images your mind creates. Don't stop at the first one. More ideas will come if you look for them. Experiment with the arrangement of values and shapes.

PUT INTUITION IN CONTROL

Let your imagination and intuitive senses of composition assume control. The hardest part about this is believing in your ability to do it. The second-hardest part is shutting off that little left-brain voice that says, "This is stupid. It won't work." It takes courage to step into the unknown and trust what you find, particularly when the unknown is within you.

WORK SKETCHES INTO REAL SUBJECTS

In the final stage of this process, let your imagination and your mind's abilities make sense out of your random marks. In other words, your imagination will harvest the visual seeds that your intuition has planted. With practice, you will develop your own method of working abstract sketches into real subjects, and in the process you will discover the endless supply of ideas for pictures that resides within you.

RESEARCH FOR DETAIL AND ACCURACY

Let me emphasize that this "abstract to real" approach is to help you develop an idea for a composition. It will not produce the finished, detailed sketch that you will need for a painting. Once you have an idea for a composition, you must do the research necessary for detail and accuracy. For example, my composition may suggest a floral arrangement. I must now decide what kinds of flowers I want and research them so I can draw them with accuracy. My composition may have suggested a building. It is up to me to find an appropriate building that I can use for reference.

COMPOSING WITH INTUITION

This is the phase of picture making where you decide how to portray your vision. It is during this process of organizing and arranging the parts of your picture that you can use intuition in partnership with your experiences and analytical art knowledge to make some of the decisions. This applies to preliminary sketching as well as the painting stage. Here is an example of a picture developed from an intuitive abstract sketch.

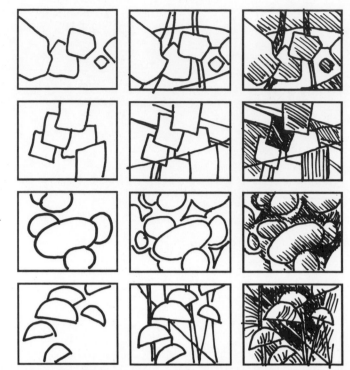

Column 1 Column 2 Column 3

VARIATION A: PUT DOWN SHAPES, LINES AND SHADING

Put down a pattern of overlapping shapes from one side of the frame to the other (Column 1). There is no restriction on the size, number or location of shapes, but they must be similar. Suggest movement by adding lines that flow through the arrangement of shapes and off the paper (Column 2). These can be of any type or direction and may suggest depth or movement. Arbitrarily shade sections (Column 3). Establish greater contrast around one shape. This will become a focal point. Shade values for other parts.

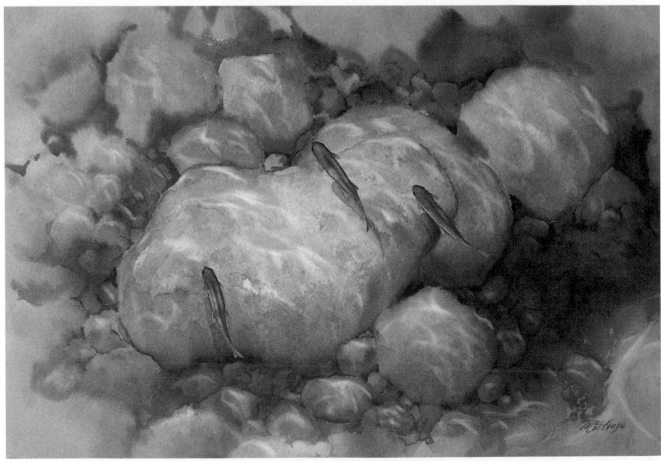

PAINTINGS DEVELOPED FROM VARIATION A

Just to give you an idea of how approach two works, here are two examples of real paintings that eventually developed from the abstract sketching of Variation A.

CURRENT EXPLORERS
15" x 22" (38cm x 56cm)
Private collection

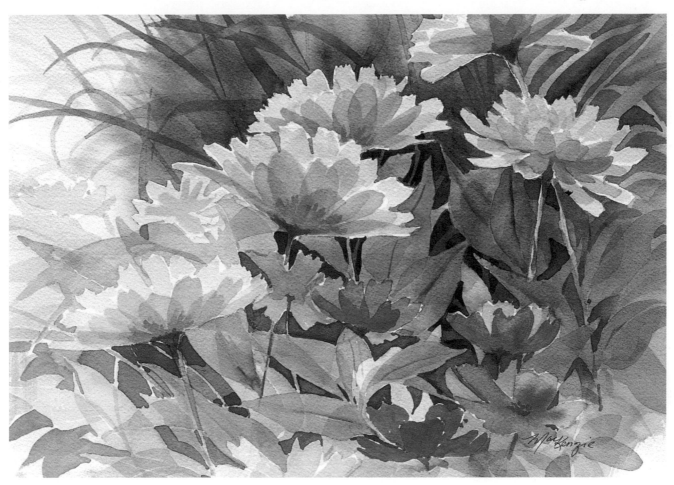

SUMMER DANCERS
11" x 15" (28cm x 38cm)
Private collection

VARIATION B: SHADE AND EMBELLISH SHAPES

Arbitrarily shade two or three dark, irregular shapes, beginning from different sides of your frame and protruding into the picture (top row). Think of this as negative space, and focus on the white area. Using your intuition, add marks and shading to make the white shape more interesting. Do not make something real yet, just embellish the shape (bottom row).

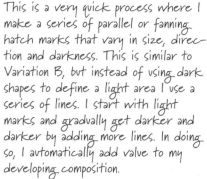

VARIATION C: DEFINE AREAS WITH LINES

This is a very quick process where I make a series of parallel or fanning hatch marks that vary in size, direction and darkness. This is similar to Variation B, but instead of using dark shapes to define a light area I use a series of lines. I start with light marks and gradually get darker and darker by adding more lines. In doing so, I automatically add value to my developing composition.

VARIATION D: START WITH A HOOK SHAPE

Here I started with a hook shape that entered the picture space from one of the sides. As you can see, there are many ways to do this. I then embellished the path of the hook with random shapes and marks that are similar in nature—jagged, circular, swirling, hatch marks, etc. I know that the eye will follow the hook to its tip, making it a perfect place to put a focal point later. There are endless variations on the same hook.

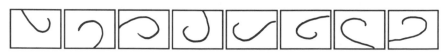

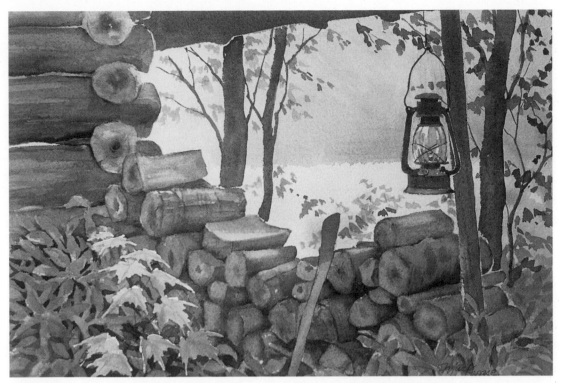

FINAL RESULTS OF TWO VARIATIONS
Here are two final results on the same "hook" composition.

SUMMER LIGHT
11" x 14" (28cm x 36cm)
Private collection

SULFUR
11" x 14" (28cm x 36cm)
Private collection

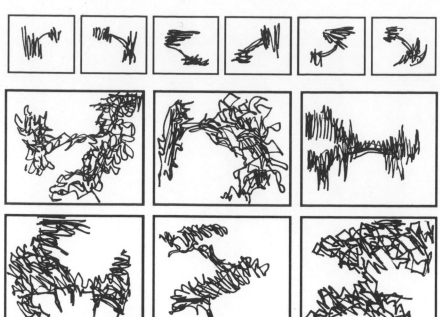

CREATE A BRIDGE

Create a "bridge" from one area of the picture to another without lifting your pencil. Bridges can go in many directions. Start from one side. Draw marks with a continuous line that extends toward another location. Let your instincts guide your pencil. Your bridge may have vertical and horizontal protrusions that reach to the margins. Don't make a perfectly symmetrical bridge, but one where one side is larger and more intricate than the other. Do not center it either.

PICTURE DEVELOPED WITH BRIDGE COMPOSITION
Here's an example of a picture that was developed with a bridge composition. Note how the larger mass on one side of the picture connects to a lesser mass on the other.

ROCK'S EDGE
15" x 22" (38cm x 56cm)
Private collection

MANY IDEAS FROM ONE THUMBNAIL
A single thumbnail sketch can generate more than one idea for a picture.

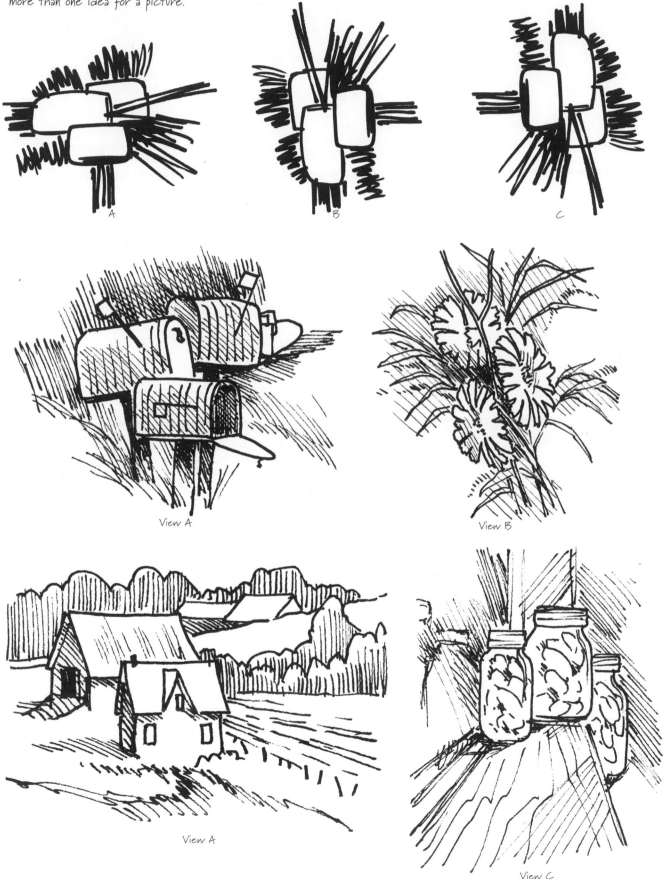

View A

View B

View A

View C

Approach Three: Working From Memory and Imagination

This is a combination of Approaches One and Two. Look inside yourself, to the endless selection of images you have already stored away from a lifetime of experiences.

The picture you produce does not have to be an accurately detailed record of a specific thing or place. Your prime objective is to recapture the essence of an experience as you recall it.

Our memories have emotions attached to them. The stronger the emotions attached to a memory, the more vivid the visual image you have, and vice versa. Therefore, this process will work best with topics or experiences about which you feel very strongly. Familiarity improves your memory. Your images of flowers improve if you take up gardening. You will know more about painting mountains if you see and paint them frequently.

Close your eyes and imagine yourself returning to an enjoyable place. Let the images and impressions of that place flash before you.

Define the underlying emotions that you remember about this situa-tion, then look for the causes of those feelings. Perhaps it was the quality of the colors, the tempera-ture, the time of day, the feel of the wind, the sunlight or some unique atmospheric conditions that impressed you. Use these things to recapture the essence of this place in a picture.

QUICKLY MAKE A THUMBNAIL SKETCH

Choose a specific aspect that appeals to you. Quickly make a thumbnail sketch that captures the basic layout of this image. Begin to enhance the image by defining and arranging shapes and values to approximate your memory or simply to suit your liking. Imagination and artistic license obviously play a major role in this part, as does knowledge of design, but uppermost in your thoughts should always be the recapturing of an emotional experi-ence. In your sketch, incorporate some of those influencing elements you identified earlier in the process. Since you can achieve some of them only with color and painting tech-niques, you might have to wait until the painting starts before you can incorporate those aspects.

SKETCH COMPOSITIONAL VARIATIONS AND DETAILS

Redraw a "memory" sketch several times in order to explore compositional variations and clarify details. Remember, no matter how good your recall, you still may have to improvise in areas where you cannot remember details. On the other hand, knowing that memory is an impression of an experience colored by feelings, if you work from memory you can work without the distractions of peripheral details. What you do not remember exactly, you render the way you want it to be or the way the picture needs it to be. Your imagination can manipulate and generate an endless stream of images that add to what you remember.

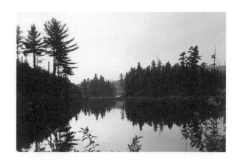

EXAMPLES OF WORKING FROM MEMORY

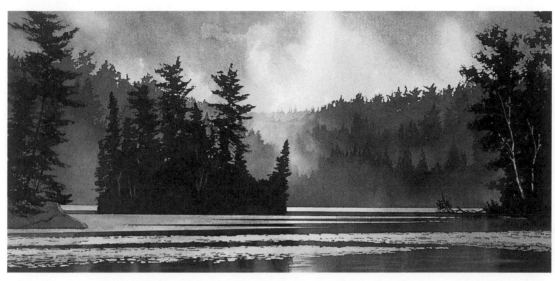

SOLITUDES
11" x 22" (28cm x 56cm)
Collection of the artist
Photographer: Ken Dobie, Kevanna Studios

In Solitudes, I wanted to go beyond the pervasive stillness that dominates so many northern lakes and say something of the spirit that moves across the water and land.

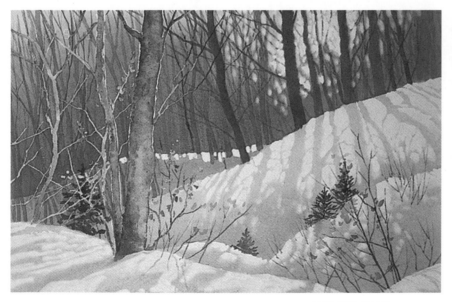

I have spent many hours on the winter trails near my home. Winter Rays is an impression from one such outing. In it my objective was to recapture the moment in which the warmth of the winter sun spread out before me.

WINTER RAYS
11" x 15" (28cm x 38cm)
Private collection

Developing a Series of Paintings

Sometimes a subject or concept is so rich that it warrants more than one attempt to capture it—your group of pictures could become a series. Some features common to most paintings include subject, value and lighting (see pages 110–113), distance from subject, point of view, values, shapes, patterns, lines, colors, techniques, etc. To do a series, keep as many features as you can the same while using one major aspect as a variable. Often there are one or two minor variables, but in the end the pictures should look as if they belong together. The five series that follow explore interesting variables.

MAJOR VARIABLE: SEASON
The technique (multiple masking—see page 56) and the subject (woods) remain the same.

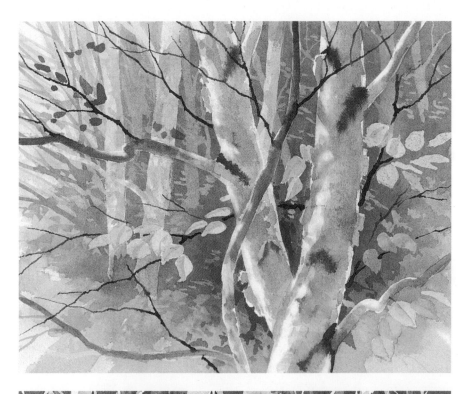

MAJOR VARIABLES: DISTANCE FROM SUBJECT AND POINT OF VIEW
Minor variable was composition. The rest stayed the same.

MAJOR VARIABLES: FLOWERS AND COLORS
The technique, numbers of blooms, point of view, style, distance from subject and technique are the same.

MAJOR VARIABLES: TEXTURES, PATTERNS AND COLORS
In this painting, the general subject (a door and window), the season and technique are the same.

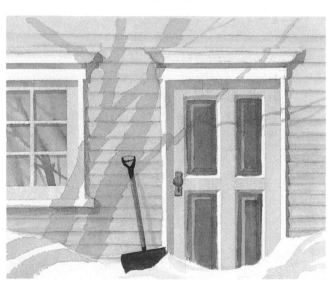

MAJOR VARIABLE: COLOR SCHEME
Composition, style, season, etc., remain the same.

Phthalo Green, Red Rose Deep, Raw Sienna

Cobalt Blue, Burnt Sienna, Raw Sienna

Indigo, Indian Yellow, Cadmium Red

PAINTING WITH INTUITION

Every time you decide to do something, you open doors to other possibilities. This does not mean you have to deviate from your plan when painting, but be aware of options and your intuition can help you decide which way to go. When you pick up the brush to add color to a wet area, realize that you could choose a different brush, a sponge or a knife. You could pour on the paint or spatter it with a toothbrush.

Sometimes you set your direction, then close your eyes and mind to other possibilities. You see any variation or happy accident as a mistake that you must correct, instead of an opportunity on which to build. Keep your mind open and your intuition ready to chart a new direction. Remain open to opportunity and options. Let your intuition play a role in the decisions you make.

Intuition vs. Planning

Beginners and experienced painters alike often tighten up when faced with a new challenge. They squirt out a millimeter of paint, hunch over their work with a steel grip on their smallest brushes, and work away, wet on dry, in terror of making a mistake.

Watercolor can be a difficult and sometimes bewildering medium unless you learn to lighten up a bit. The following pages take a close look at things you can do to improve your spontaneity and, in turn, increase your enjoyment of the medium. It even suggests ways to save pictures, just in case your spontaneity runs amuck.

INTUITION

Artists rightfully draw on knowledge gathered from experience to make decisions. Yet there is a deeper level of knowing that resides in your subconscious that you can access as well—it is your intuition. Intuition is not a substitute for experience, however, because the more you understand about perception, composition and techniques, the more informed your intuitive decisions will be. Pay attention to the rules, but do not ignore your intuition. Think of the creative process as a bridge between rules and some insight trying to be born of a greater wisdom that resides within us all.

Unfortunately, you cannot will creativity, insight or intuition. All you can do is will yourself to approach your work with daring and the openness of mind that invites them in.

Listen to your intuitive sense at all stages of the picture-making process. This is a major challenge, because it means trusting and believing in your own good judgment. The more you call upon your intuition

for direction, the faster and clearer it will come.

PURSUING THE VOICE FROM WITHIN

We artists have images of how we would like to paint. No matter what your skill level, the desire to express ideas in a way different from what you are currently doing seems to be common. A preferred style of expression swirls in and out of consciousness as you work. A successful painting is not your final accomplishment, just another level of achievement on the way to your goal, which may seem vague at times. However, the vision, along with the joy of painting, leads you on, to keep you coming back again and again to attempt to achieve it. The diligence with which you pursue your vision determines your artistic growth. This goes beyond mastery of manual skills and techniques.

When my students describe how they would like to paint, the vast majority see images that are freer, looser and livelier than what they are currently producing i.e., more spontaneous. Spontaneity suggests confident, deliberate and intuitive movement or action. Artists who work spontaneously seem to know instinctively what to do. Every move is confident, as if they are directed by a force unseen. They move quickly, seemingly focused on the whole work and unconcerned with little details until the time is right. They know where they are going, and they seem to know how to get there. Working more spontaneously means trusting your intuition.

No one can make you more spontaneous unless you want to be, but having chosen watercolors, you at least have chosen a medium that is highly sympathetic to spontaneity.

PHYSICAL AND MENTAL BLOCKS TO SPONTANEITY

A PALETTE WITH SMALL WELLS

A palette with small wells will not allow you to use those nice new big brushes you have just run out and bought. Sorry about that, but it will definitely slow you down if you can't get at your paint.

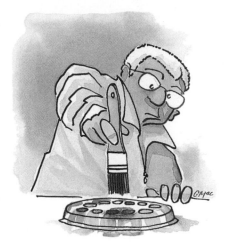

LET YOUR WORK REFLECT YOU

The desire to have your work mirror yourself, and not just the subject, is the essence of the creative process, the essence of being an artist, the essence of finding your inner creative self. It is all about finding and making your "self" visible.

TOO MANY DISORGANIZED COLORS

A palette with too many colors contributes to confusion. A smaller selection of basic colors will reduce hesitation when making color decisions. You can produce mixtures yourself. See Setting Up Your Palette on page 97.

TOO LITTLE PAINT ON THE PALETTE

You will interrupt your painting flow if you have to search for more paint. Watercolors will not go bad if you leave them to dry on the palette. The odd color may crumble in time from repeated re-wetting, but this is a small inconvenience compared to reaching for a color that isn't there while you are painting. The amount of paint you put out is an indicator of how serious you are about succeeding. Examine the palettes of experienced painters. They put out lots of paint because they know they will need it, particularly when they use their large brushes.

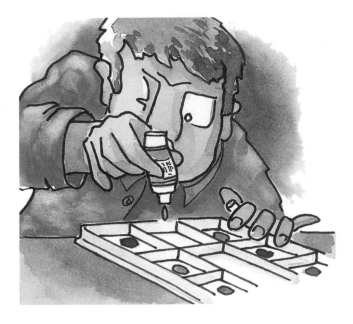

RESTRICTED MOVEMENT FROM SITTING DOWN

Sitting down keeps you from using the full movement of your arms and body. The term spontaneous suggests acting out your impulses. It is hard to do this if you are sitting on it. Also, the larger your piece of paper, the more physically demanding the painting process and the more important that you get full arm movement behind your brushes. Sitting down really does cramp your style and your spontaneity, but when you stand you should raise your table to hip height and stand on a cushioned mat to minimize back and leg stress.

INTERRUPTIONS AND DISTRACTIONS

Constant interruptions will break your flow and concentration. As hard as it may be, you must try to find a time and place where there will be minimal distractions, particularly conversation with others. Have you ever noticed how hard it is to stay focused in a workshop situation where other people want to carry on a conversation? Some may prefer to work in silence, while others find music a powerful tool for remaining centered on this right-brain activity.

FATIGUE

Being tired is a real killer of spontaneity. Painting is a process that demands great mental strength and physical stamina. Working spontaneously is the most demanding because you must be constantly alert and totally involved in the process.

Life often leaves little time and energy for painting. However, artists who paint on a regular basis and for sustained periods of time are likely to be freer in their approach than those who paint only occasionally. When you return to painting after a long break, it takes time to get back in the swing of it. If you feel as if you have almost forgotten how to paint, it is highly unlikely that you will approach it spontaneously.

WORKING ON ONLY ONE PAINTING AT A TIME

It is easy to overwork a picture when it's the only one on which you are working. Have several on the go at any one time. If things are not going well or you are not sure what to do next, put one away and work on another. When you return to the original, your fresh view often will indicate what you need to do. At any time, I have twelve or more paintings at various stages of completion.

Stop work on a painting when you reach a "high" and all is going well. Walk away with your attitude one of "winning," and you will be eager to get back to it. If you have only one painting, you have to quit when things are not going well. Your feeling is of defeat, and it will be hard to get back to painting.

BRUSH SIZE AND WORKING SMALL

Over-reliance on small brushes will also slow down spontaneity and produce an overworked appearance. You will spend more time carrying paint to the paper than you will spreading it around. If you have become comfortable producing small paintings, chances are you are also overusing small brushes. By increasing the size of your pictures, you will be obliged to use larger brushes and bold strokes to cover large areas quickly. This is particularly critical in the beginning stages of a work when you often want to deliver a lot of paint for a background passage. As a rule of thumb, try to paint as long as you can with your biggest brushes (1½" to 2½") and save the small ones for detail at the end.

ALWAYS USING THE SAME TECHNIQUE

If you always work wet-on-dry, you are missing out on the medium's most exciting feature. It's the wet-in-wet approach that helps produce much of the free and spontaneous appearance of your work. This is understandable, because it's in this state that the paint takes on a life of its own. The pigments flow and react to water in ways that you cannot always plan. These techniques demand a give-and-take attitude while you remain open and ready to react spontaneously and intuitively to opportunities and possibilities that the medium presents.

WORRYING ABOUT WASTE

You might waste valuable time and materials if you take chances and ruin your picture. You're right—you just might. You might lose lots of paper and paint and time, but that's the price and the chance you have to take. Painting more freely is about taking chances, and this is just one of them. By "wasting" time and materials, you will open creative doors you never knew existed. You will derive far greater enjoyment from the painting process because you will grow and learn much faster. You will want to paint often, so you will produce far more work that, along with better planning, will quite likely reduce the chance of wasting time and materials in the long run.

THE SMELL OF FEAR

Besides physical blocks to spontaneity, there are some very real and powerful mental blocks, chief among them being fear: fear of making a mistake, embarrassment, ridicule, exposing deep secrets and artistic inadequacy. Take your pick. Any one of these phantoms is enough to scare the living "spontaneity" right out of anyone. We spend a lifetime developing all means of protection for our egos. We will do anything to avoid embarrassment. Why would we ever want to let our guard down and compromise ourselves like this? Because it's the price we all must pay in order to break loose and soar.

To work spontaneously we must screw up our courage and stare down these phantoms. In truth, most of your fellow artists do not spend a lot of time worrying about your inadequacies anyway. They have enough problems dealing with their own. They will, however, envy your strength of conviction and the results you get.

WHERE ARE YOU GOING?

Think of painting as taking a week-long vacation. Most of us would not just walk out of our homes, jump in the car and wander merrily down the road for seven days without knowing where we were going. Many of us paint this way, then wonder why we never seem to get where we want to go.

Working spontaneously does not mean working without a plan. If you want to successfully arrive, you must at least have a general idea of where you want to go—that is, what you want to say or capture and how it will appear. This may mean exploring the subject with thumbnail sketches or value studies first to find or clarify a plan that will best express your vision of the subject.

PLANNING KEEPS YOU IN CONTROL

For that week's trip you would undoubtedly give some thought to a destination. You might consider various routes and stopovers along the way. You would consider the things you need to take and maybe even things to do at various stages on your way. You feel more comfortable if you think about these details. You also know that if your plans are flexible enough to take advantage of some of the unexpected little treasures that might pop up, you will get even more enjoyment from the journey. If you plan ahead, refer to travel brochures and make reservations in advance, it allows you in some small way to feel that you are in control of your destiny. You are more confident that your trip will be a success.

You must also consider beforehand how you are going to get where you want to go and in what sequence. That is, what techniques will you use, and in what order? What colors would best convey the feeling you wish to express? What size and format will the picture be?

Don't forget supplies. Have you put out enough paint on the palette? Have you located the main brushes and other tools you will use in the process so you don't have to interrupt the flow while you hunt for them?

All successful artists develop unique ways of planning their work, not because someone told them to, but because they have found advantages to doing so. Take the time to think out your painting beforehand. You will be able to work with greater confidence while still remaining open to options and opportunities that come your way.

THE PHANTOMS OF FEAR

STAY OPEN TO POSSIBILITIES

When you paint, there is no guarantee that you will arrive at the exact location you had planned. The only guarantee is that if you have not done some planning beforehand, you will not even come close or will quite likely end up in the ditch. Painting is a nebulous process of compromise and surprise. You must accept destinations that are not quite the way the brochure describes them but nevertheless quite acceptable.

REALISM

Not every painting has to be a super-realistic depiction of an actual subject. Paintings can be born of your mind's eye, memory and imagination. They can be a compilation of things and places. You can render them in whatever way you desire. Realism that reflects a slavish adherence to the literal appearance of the subject is not a measure of quality. This is realism for realism's sake and is more a measure of the painter's technical skills than of his or her creative abilities.

You should strive to produce work that reflects the creative decisions you have made, be it in a realistic fashion or any other. Even paintings that contain high realism can have passages that suggest a spontaneous approach. Images that reflect our "self" have an all-important emotional impact not usually found in literal "copies" of a subject.

DEVELOPING A STYLE

The style of your work is a reflection of your personality and physical dexterity. It will develop naturally, over time, as you learn to trust your innate ability to make intuitive artistic decisions regarding subject, composition, color and techniques. Don't be surprised if you develop several styles. After all, you see the world in different ways. Why shouldn't you be able to express yourself likewise? Remember, precious gems have many facets.

To Save Or Not To Save

Let's face it. No matter how much you want to resurrect a work, the reality is that you cannot save all works, and to waste time trying will only add to your frustration. This section is also about determining which pictures may be worth saving, which ones to forget and the techniques to try.

ANALYZING THE PROBLEM

Squint. This eliminates distracting detail so you can study values, big shapes and major lines.

Mirror. Try looking at your work in a mirror. It provides a fresh view of your work.

Stand back. This also eliminates much detail, allowing you to see problems with value and unity. If things fade out or are unclear at a distance, that may be your problem.

Reducing glass. This is just a concave lens. Hold it up and view your work through it. It allows you to see

your work at a distance—but in detail. This may help you spot confusing patterns, edges and values.

Turn down the lights. This is a good way to check values and big shapes. The basic structure and focal point should be discernible even in low light.

The "L" with it. Cut an old mat at opposite corners to make two Ls. Lay these on your work and play with the format. Eliminate or save what you want.

Put it away. Getting a problem picture out of sight for a while often helps. When you come back to it, any problems with the work will stand out immediately, but just for a second or two.

Rose-colored glasses. Viewing your work through a piece of red acetate helps you see the value of your colors and any problems between them.

MAKING CHANGES—
FIRST, THE BAD NEWS...

The following problems are nearly impossible to change, even with a great deal of effort. Just turn your paper over and start again.

- mistakes in perspective, structural or perceptual logic
- poor position of major shapes
- the size of objects
- tight brushwork that says "over worked"
- too many colors
- colors that have become muddy
- staining colors where you wanted to lift paint
- paper that has lost its sizing (a substance that limits absorbency of watercolor paper) or developed mold
- scratched and overworked surfaces
- masking that is sloppy or has torn the paper

...NOW THE GOOD NEWS

You can usually correct the following common problems without too much risk. Essentially, any method that maintains the freshness and spontaneity of a work while remaining indiscernible, is acceptable.

Problem:
Run-Backs and Hard Edges

Action
Let the paper dry completely. Wet only the area of concern and gently scrub the edge of the run-back (water spot or blossom) or hard edge with an old, stiff synthetic brush. If you use a new one, you will ruin its tip. When the edge disappears, blot with a tissue. If it was a run-back, you may now replace color to this damp area. A natural elephant's ear sponge or soft toothbrush may also work. Use lots of water, and scrub gently in a circular motion. If the paint was a staining color, you may not be able to remove it without going right to white paper.

Next Time
Keep an eye on damp areas. They are most vulnerable to excess moisture that comes in contact with them. Keep a large, damp brush handy to fade out hard edges before they can dry.

Problem:
Incorrect or Ineffective Values

Action
By squinting, you will see the area or objects that need greater contrast. Darken one or the other with a color already used. You can use an all-over, transparent glaze to join small or fragmented patches of similar values into larger masses.

If you must lighten an area, you can remove paint using water and a soft sponge. Staining colors are the

hardest to remove. You may need to redefine the dark edges that border the area you have scrubbed. Do so when everything is dry.

Next Time
Plan your values with a thumbnail sketch beforehand. You need only worry about a few values—lights (including white), mid-values and darks (including black). By limiting your palette, you will have to make more contrasts by value instead of colors alone. Get in the habit of squinting at your work as you paint.

Problem:
No Particular Mood Evident

Action
Dominant temperature, brilliance (purity) and value of colors determine mood. The position and types of shapes and lines (movement) also contribute to a picture's mood. You can usually change colors and values. Try glazing most of the painting with a transparent color in the temperature you wish. Don't overdo it. Save some white, particularly near the focal point and other areas. Soften the edges of the glaze area. The darker the glaze, the lower the total value of the painting becomes.

Next Time
Decide the feeling you want before you start, and select your color scheme accordingly (see page 114). A thumbnail sketch can help you choose the dominant value for the work (see page 122).

Problem:
Focal Point Hard to Find

Action
The eye sees all parts of the picture equally because you have evenly distributed values, details and colors. You can subdue and unify unnecessary detail by scrubbing back or glazing over with a transparent color. Increase the detail and contrast around the center of interest. This can be a problem if you have made it very small. To move the viewer's eye into the focal area, try glazing and darkening the corners and sides of the picture with a cool color.

Next Time
Save your detail and highest contrast for the center of interest. Other areas should help the viewer focus on this spot by being less attention grabbing.

Problem:
Highlight or Dark Detailing Missing

Action
Squinting will point out where you need values. Scrub out highlights with a small hog hair scrubber and water, or carefully scrape with a razor blade. Paint in darks as needed, particularly next to areas you want to highlight.

Next Time
You might consider masking in order to save some of the highlights.

Problem:
Misplaced Looseness

Action
The edges, in particular the corners of major shapes, need care so the viewer can read them easily. A loose edge may read as sloppiness. If you mangle a lot of major edges and corners, it may be easier to start again.

You may be able to clean up sloppy edges by scrubbing with a small hog hair scrubber. When dry, redefine the edge with paint. For a precise edge, use the edge of a piece of clear acetate as a mask and scrub the area with a wet toothbrush. Blot excess water immediately.

Next time
Save loose edges for less-important areas and parts of shapes where you want the eye to keep on going.

Problem:
Paint Splatters

Action
Only worry about the ones that are really distracting, that you cannot work into your composition. Be very careful with the ones sitting on heavy-colored backgrounds. You don't want to replace a dark splatter with a white blotch. Splatters on very light backgrounds are the easiest to remove.

Carefully wet the spot with water and let it stand a moment. Depending on the size of the splatter, gently scrub with an old, stiff synthetic brush, a soft toothbrush or a hog hair scrubber. If the spot is on a heavily colored background, you may need to scrub off a larger area with the soft toothbrush and then repaint it. Make sure the edges of the removed area fade smoothly into the surrounding colored area.

Problem:
Small Paint Dots

Action
Carefully pick off with the tip of a craft knife and then erase.

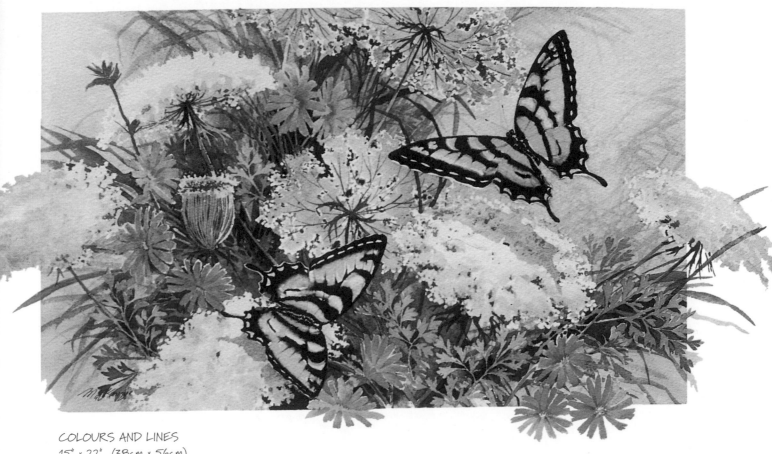

COLOURS AND LINES
15" x 22" (38cm x 56cm)
Private collection

Gallery

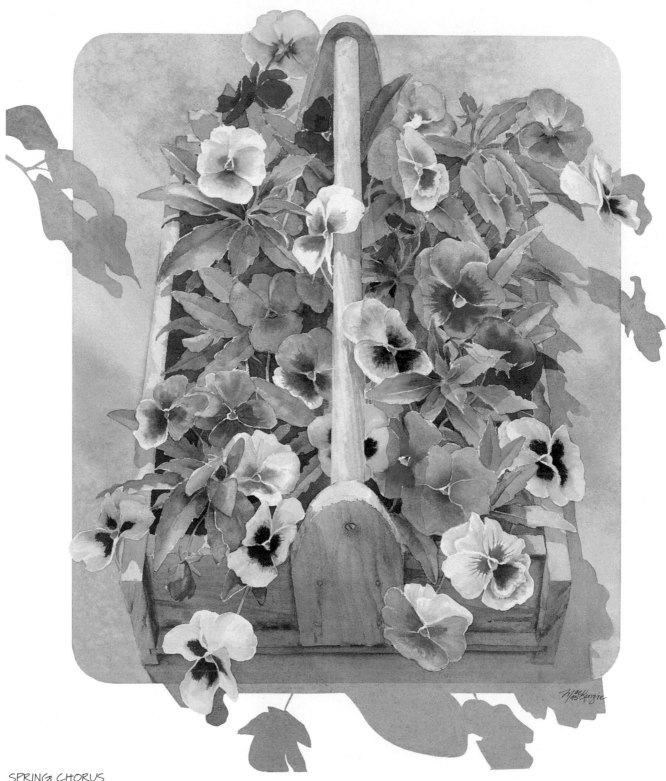

SPRING CHORUS
19" x 22" (48cm x 56cm)
Collection of the artist
Photographer: Kevin Dobie, Kevanna Studios

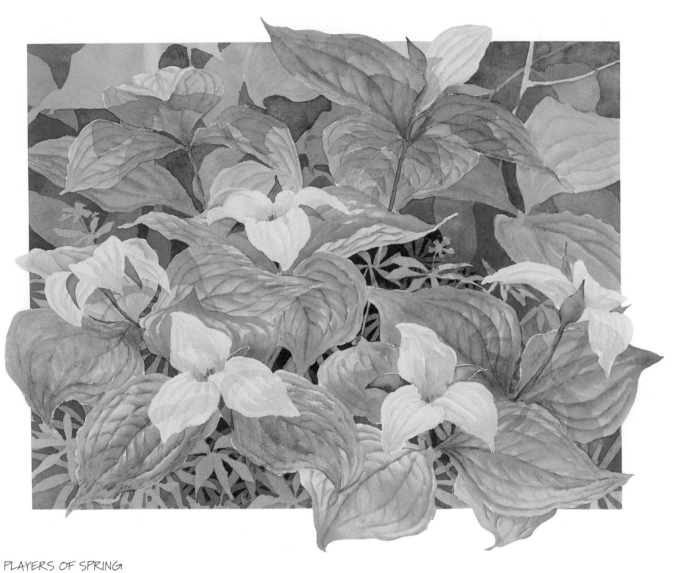

PLAYERS OF SPRING
19" x 22" (48cm x 56cm)
Collection of the artist
Photographer: Kevin Dobie, Kevanna Studios

MEMORIES
22" x 30" (56cm x 76cm)
Collection of the artist
Photographer: Kevin Dobie, Kevanna Studios

GATHERING OF THE CLAN
11" x 22" (28cm x 56cm)
Collection of the artist
Photographer: Kevin Dobie, Kevanna Studios

INDEX